SIGNALLING AND SIGNAL BOXES

on the Great Northern Railway Routes

Allen Jackson

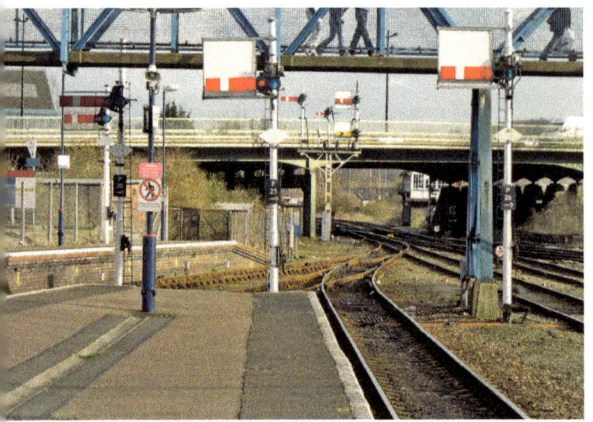 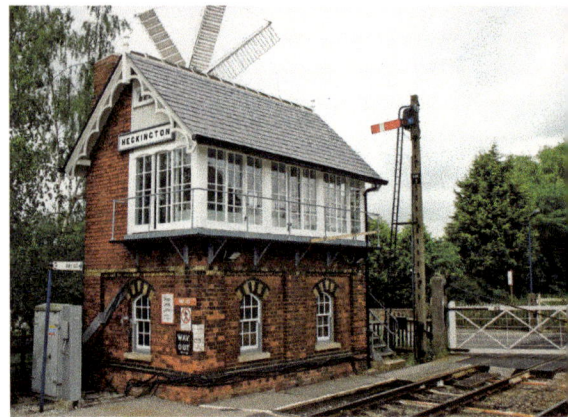

Left: Pelham Street Junction signal box and some of its signals. February 2005.

Right: Heckington signal box and LNER concrete posted signal. May 2007.

For Ninette.

First published 2017

Amberley Publishing
The Hill, Stroud,
Gloucestershire, GL5 4EP

www.amberley-books.com

Copyright © Allen Jackson, 2017

The right of Allen Jackson to be identified as the Author
of this work has been asserted in accordance with the
Copyrights, Designs and Patents Act 1988.

All rights reserved. No part of this book may be reprinted
or reproduced or utilised in any form or by any electronic,
mechanical or other means, now known or hereafter invented,
including photocopying and recording, or in any information
storage or retrieval system, without the permission in writing
from the Publishers.

ISBN: 978 1 4456 6746 1 (print)
ISBN: 978 1 4456 6747 8 (ebook)

British Library Cataloguing in Publication Data.
A catalogue record for this book is available from the British Library.

Typeset in 10pt on 13pt Celeste.
Origination by Amberley Publishing.
Printed in the UK.

Contents

Introduction	5
Summary of Contents	6
Great Northern Railway (GNR)	8
Lincoln to Gainsborough GNR	9
Nottingham to Skegness	48
East Coast Main Line and Doncaster to Gainsborough	83
References and Acknowledgements	95

Introduction

The London and North Eastern Railway was one of the four constituents of the 'Big Four', but the identity of the larger pre-grouping companies within the LNER persisted and does so to this day. Lines are referred to by their pre-grouping ownership by Network Rail and others even now.

The only pre-grouping railways considered are those for which an identifiable signalling presence existed at the time of the survey.

Note: the volume of the Great Eastern Railway in this series also contains information on ways of working and signal box lever layout and use, as well as listing and other information.

Summary of Contents

Great Northern Railway (GNR)

LINCOLNSHIRE to NOTTINGHAMSHIRE

LINCOLN to GAINSBOROUGH GNR
Pelham Street Junction
High Street
East Holmes
West Holmes
Saxilby
Stow Park
Gainsborough Lea Road

LINCOLN to PETERBOROUGH
Blankey
Scopwick
Sleaford North
Sleaford South
Blotoft
Gosberton
Mill Green
Spalding
Littleworth
St James Deeping
Eastfield (Peterborough)

NOTTINGHAM to SKEGNESS
Netherfield Junction
Rectory Junction

Bingham
Bottesford West Junction
Allington Junction
Ancaster
Rauceby
Sleaford West
Sleaford East
Heckington
Hubberts Bridge
West Street Junction
Boston Dock Swing Bridge
Sibsey
Bellwater Junction
Thorpe Culvert
Wainfleet
Skegness

EAST COAST MAIN LINE and DONCASTER to GAINSBOROUGH
Offord
Helpston
Tallington
Claypole
Barnby
Bathley Lane
Carlton
Grove Road
Barnby Moor and Sutton
Ranskill
Finningley
Beckingham

Great Northern Railway (GNR)

The Great Northern Railway's principal destination was York on its eventual ambition of running expresses to Scotland. The railway had a slice of the lucrative coal traffic in Nottinghamshire to the major cities of the Midlands and North. There was also joint traffic in the south Yorkshire coalfield.

The GNR expanded to have a presence in Leicester, Nottingham, Derby and Manchester. The Great Northern goods warehouse in Manchester stands to this day. The railway had a third share in the Cheshire Lines Committee and so got to Liverpool, Southport and Chester.

Most of these GNR lines to outlying destinations were early victims of closure.

The intensive suburban lines out of King's Cross together with its main line were an early candidate for modernisation. There had been two serious accidents at Welwyn Garden City in 1935 and 1957, and the first vestiges of mechanical signalling appear around Peterborough and in the secondary lines of Lincolnshire.

Lincoln to Gainsborough GNR

This section covers the signal boxes in Lincoln and on the line to Gainsborough Lea Road, the Great Northern station. The journey is depicted on the schematic simplified diagram at figure 3.

Lincoln has long been an administrative and commercial centre for the surrounding countryside. Its position on a hill is remarkable considering the flatness of the surrounding lands; the Romans obviously thought so too and built an early fortress here, and the then-town was called Lindum. Lindum Hill is a thoroughfare in Lincoln renowned

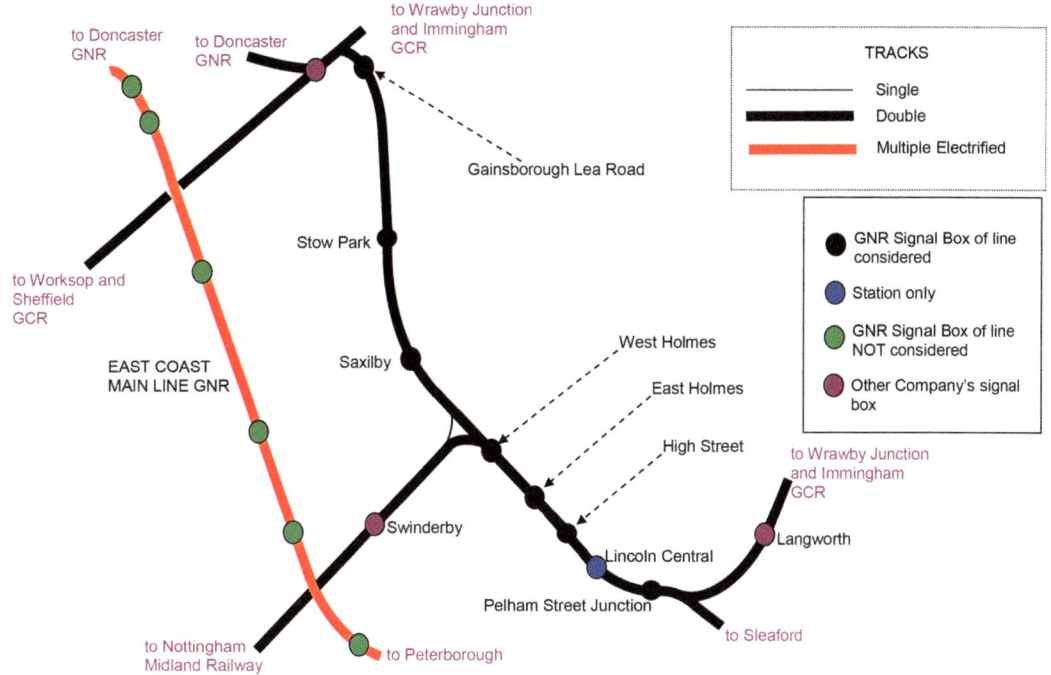

The Great Northern Railway in Lincolnshire schematic diagram.

9

for its steepness, antique shops, and the magnificence of the cathedral atop the hill. The city has many associations with the Royal Air Force and on moonlit nights, in the Second World War, bomber crews returning to their bases would use Lincoln Cathedral as a navigation aid.

The Great Northern was the primary railway company, with the Great Eastern sharing a line, and the Great Central had lines of its own.

The city was also host to the Midland Railway – later LMS – at its St Mark's station, which closed in 1985.

Pelham Street Junction (P)

Date Built	GNR Type or Builder	No. of Levers	Ways of Working	Current Status 2015	Listed Y/N
circa 1874	GNR Type 1	100	AB	Demolished 2008	N

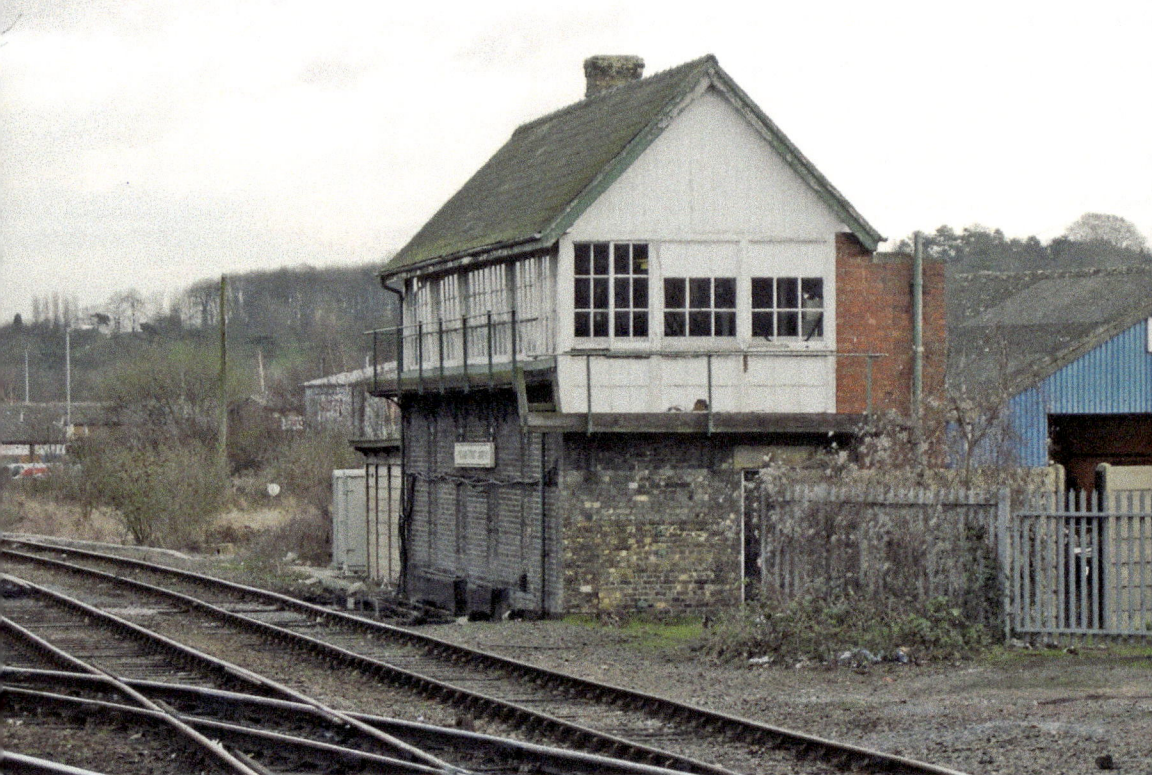

Pelham Street Junction signal box is depicted at Fig. 4 and the tracks in front of the box on the extreme left are the GC line from Wrawby Junction. Next is a point to a set of sidings that used to be a home to Diesel Multiple Units or DMUs. The steam depot was the other side of the station and the remains are in one of the succeeding pictures. After that is the GN-GE joint line to Sleaford and eventually Peterborough. On that line is Sincil Bank crossing, which is now a CCTV-controlled crossing, but once had its own box. February 2005.

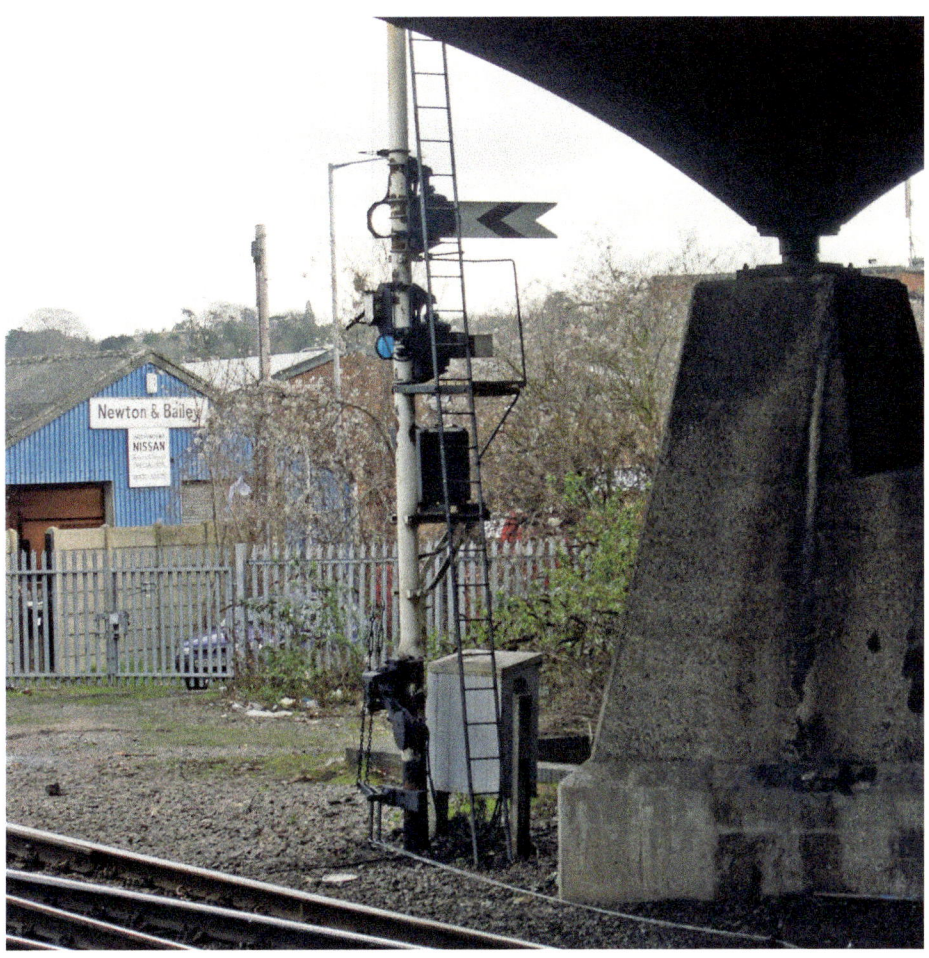

Just a bit towards the camera in the last picture is the signal that admits trains to the platforms after they have come off the junction – Fig. 5. The red and white home signal is not visible in this shot but below that is the fish-tailed distant signal. Distant signals on running lines are used to give advance warning of the state of the next signal but in station areas where signal boxes are close together, distant signals are fixed at caution. You can see that there is no green lens in the signal as it doesn't need one. Distant signals on branch lines that have a running speed of 40 mph (64 km/h) or less have fixed distant signals. Often the spectacle containing the lenses is dispensed with and the lamp just shines yellow for caution with the arm fixed horizontally.

Below that is a red and white horizontally striped signal known as a 'Calling On' arm that is used to advise a train driver to proceed with the utmost caution as the destination platform may already be occupied by another train. Below the calling on arm is a rectangular box that is a route indicator advising a driver which track is to be taken.

The bridge supports that frame the shot are part of the replacement for the level crossing with the four massive gates just referred to. The track bed to what had been St Mark's station runs in front of the grey galvanised fence. February 2005.

This journey starts at the junction of lines from the Great Central at Wrawby Junction and the joint GN and GE line to Sleaford and Spalding.

The junction was further complicated by two tracks crossing all of this from the Midland Railway St Mark's station, which joined the GC line at Durham Ox Junction, named after a local pub. As if this wasn't enough there was a large level crossing with massive gates that employed four people just to open and close the gates. This was a major source of road traffic disruption and was later eliminated by using a bridge instead.

The mileages are calculated from Huntingdon South Junction via March and Pelham Street Junction signal box was 82 miles 29 chains (132.55 km).

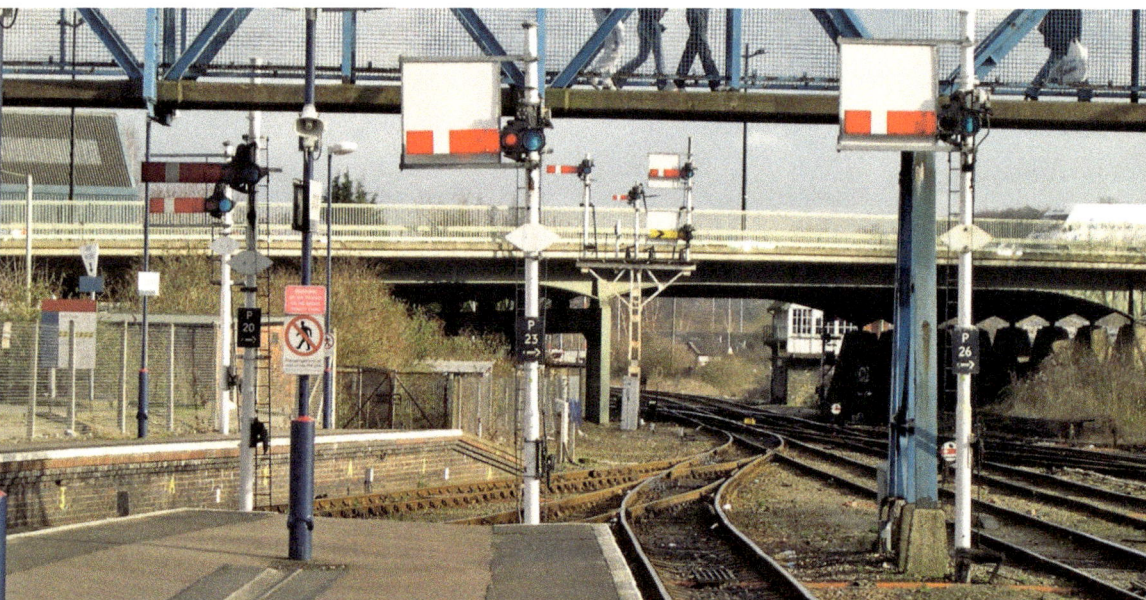

To put the last two pictures in perspective – Fig. 6 was taken from a platform at Lincoln station. There are three platform starter signals and the home signal at the extreme right is for a through road for freight trains, signal P26. Beyond the starters is a bracket signal that controls the three possible routes to take from this end of the station. From left is the GC to Wrawby, in the middle is a subsidiary or siding signal to the sidings, and on the right the joint GN-GE line south past Sincil Bank to Sleaford. There is a further small post or 'doll' on the bracket and that was for a further siding that was removed. The various heights of the posts are a rough guide to the relative speeds to be taken on particular route. Some of the signals have white sighting boards to make the arm's position stand out more against the background. The white diamond or lozenge shape indicates that track circuits are in operation.

The Up starter referred to in Fig. 5 is beyond the bridge and beyond that the box itself. The two ground signals or discs signal reversing moves over crossovers. February 2005.

High Street (HS)

Date Built	GNR Type or Builder	No. of Levers	Ways of Working	Current Status 2015	Listed Y/N
1874	GNR Type 1	36	AB	Closed 2008	Y

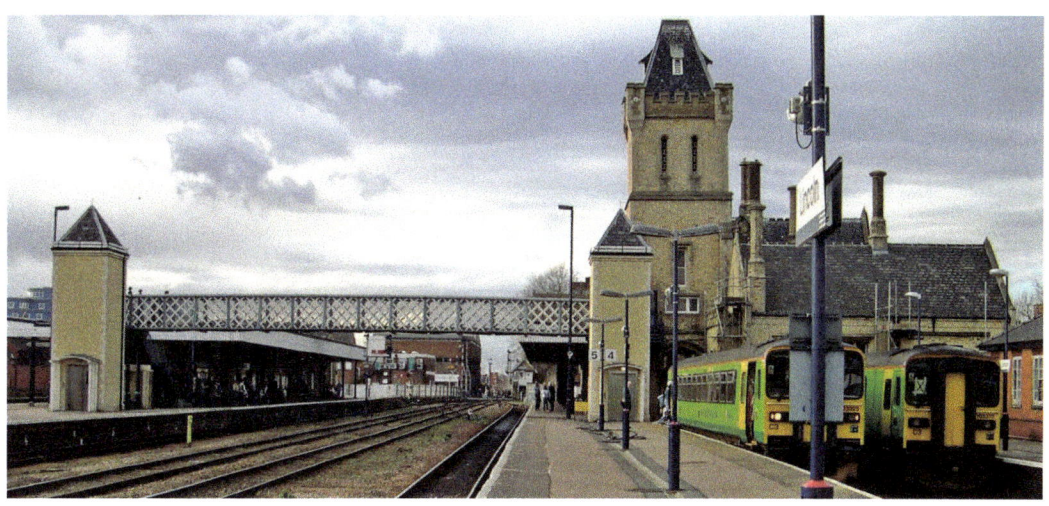

Fig. 7 is the 180 degree opposite view to Fig. 6 and the fine Lincoln Central station is on view with the two centre tracks as avoiding lines for freight trains and express passenger trains when they have been diverted from the East Coast Main Line. The left-hand of these tracks has a gallows bracket signal plated HS2. This unusual configuration is presumably to give the train driver the earliest possible sight of the signal after the train has come under the bridge by Pelham Street Junction signal box. The left-hand tracks going away from the camera are considered to be the Down direction and those on the right coming towards the camera the Up direction. Further on are High Street signal box and the road crossing.

The two DMUs in the platforms are Class 153s, 153 325 on the left, and 153 375 on the right. February 2005.

Lincoln station is an architectural gem, although not listed.

Still a source of major disruption at the survey date was the High Street road crossing.

Fig. 8 is Lincoln High Street signal box and the bane of some pedestrians' lives as road traffic sees constant interruptions. The annex on the side of the box was built to house the level crossing barrier controls after the gates were removed. The box survived the cull in 2008 thanks to its listing and there is talk of the box being moved or converted into a café. February 2005.

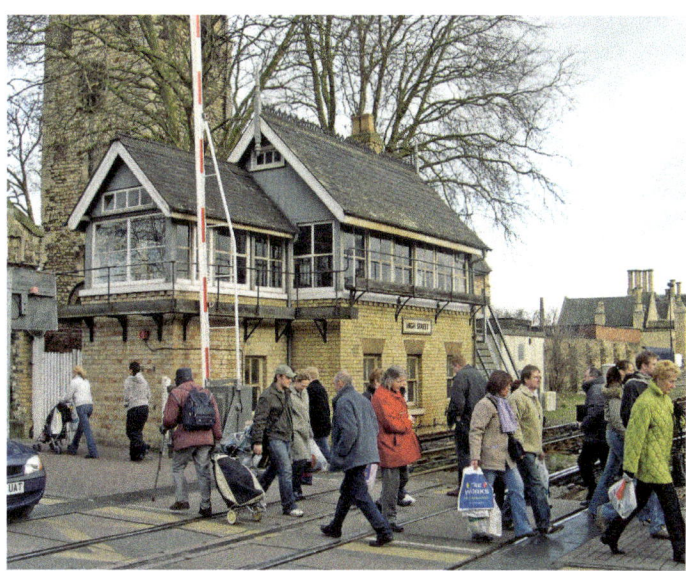

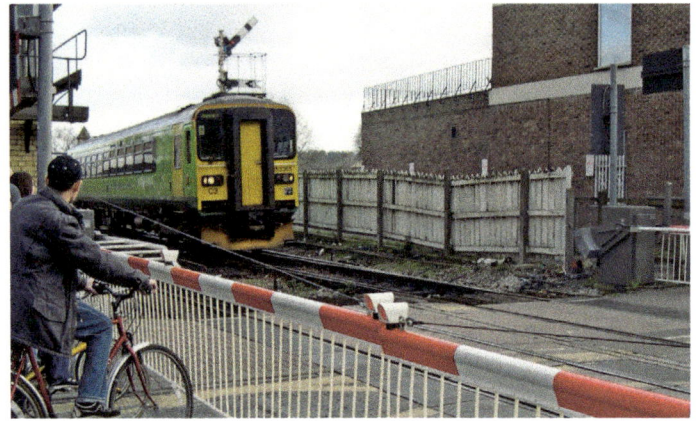

Fig. 9 and High Street signal box in operation with a single car DMU class 153 – 153 365 – heading for the Midland Railway route to Newark. Note that there is no green lens in the distant signal here either as East Holmes signal box is a short distance up the track; 11 chains (221 m) to be precise. February 2005.

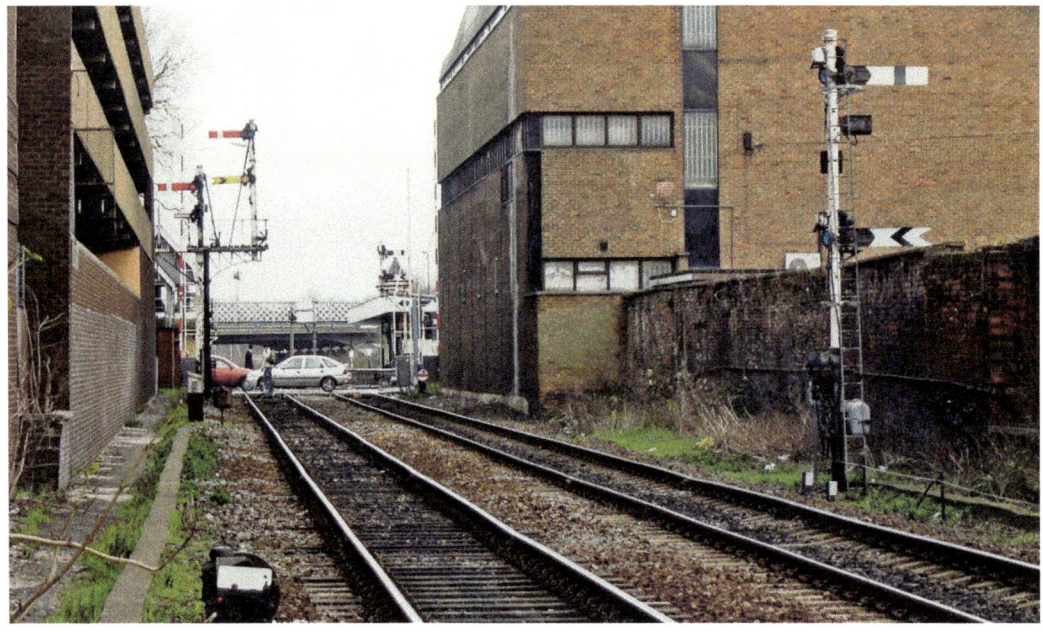

Fig. 10 and the home signal that was raised for the DMU in the previous figure is in the middle of the three, near the silver car on the crossing. The bracket signal on the left gives two routes. The left is for the platform and below it a calling on arm to admit a train into an already occupied platform. The right-hand taller post is for the through avoiding line towards Pelham Street Junction. The signal on the right is East Holmes' home signal, with West Holmes' distant beneath it. In situations where the boxes are close together but there is a need for a working distant, then to give the requisite warning to the train driver the succeeding box's distant signal is often on the post of the preceding box's home signal. There is not enough distance between signals for the distant to have its own post.

The small box below the home signal arm is an economy version of the route indicator. This type of box is known as a 'stencil box' and it can display a single character usually. In this case, there are two stencil boxes side by side and it is M for mail line or L for goods loop, of which the train is approaching in this direction. Thus, the complete indication is a raised semaphore arm together with either M or L on the stencil boxes. If the home signal is at danger no stencil box indication is given. February 2005.

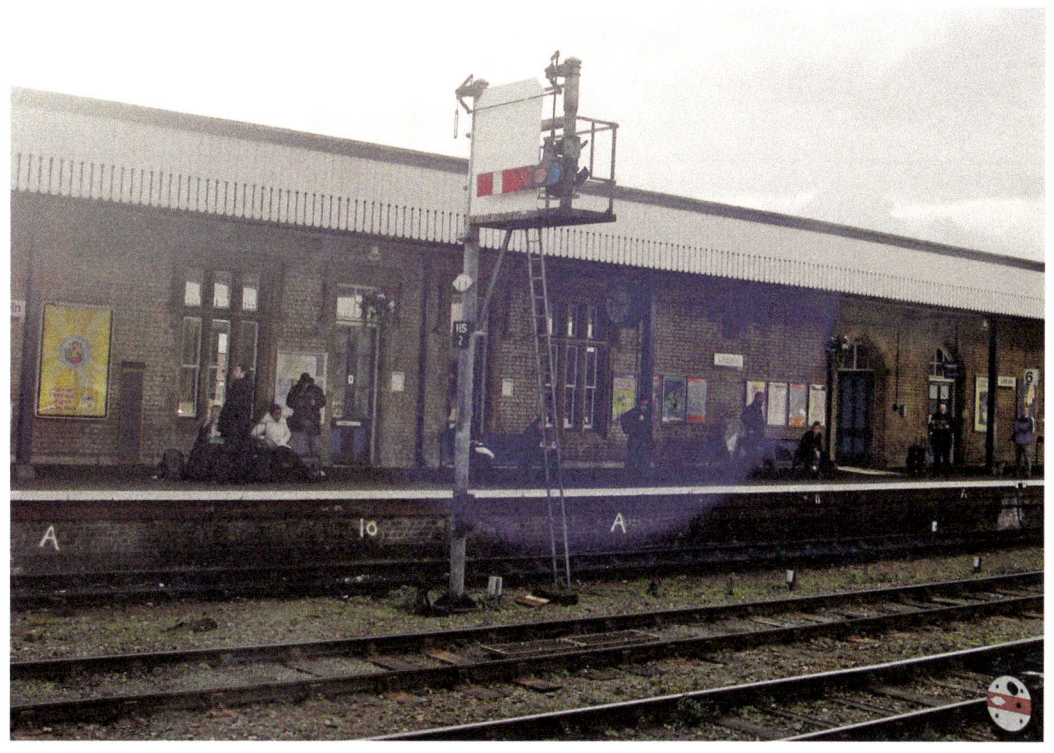

Fig. 11 and that unusual gallows bracket signal HS2. Note how the angled bell cranks transmit the movement to the signal arm. With upper quadrant signals they are usually all wire worked from the box to the arm. Here the last part of the motion is to push the arm down about its pivot for it to rise to the off or go position. Clearly a wire could not supply a push and so rods have to be employed. February 2005.

High Street signal box is 82 miles 49 chains (132.95 km) from Huntingdon South Junction via March.

East Holmes (EH)

Date Built	GNR Type or Builder	No. of Levers	Ways of Working	Current Status 2015	Listed Y/N
1873	GNR Type 1	35	AB	Closed 2008	Y

The line continues for about 200 yards (180 m) until it arrives at another road crossing at Brayford Wharf and right after that is the River Witham. The river was a trade artery in earlier times and winds its way to the port of Boston; one of the journeys in this book re-joins the river there. The box is right by the river and it was directly opposite Lincoln steam engine sheds, which survived until recent years. After the box is a pair of goods loops that run parallel to the running lines until we get to West Holmes signal box.

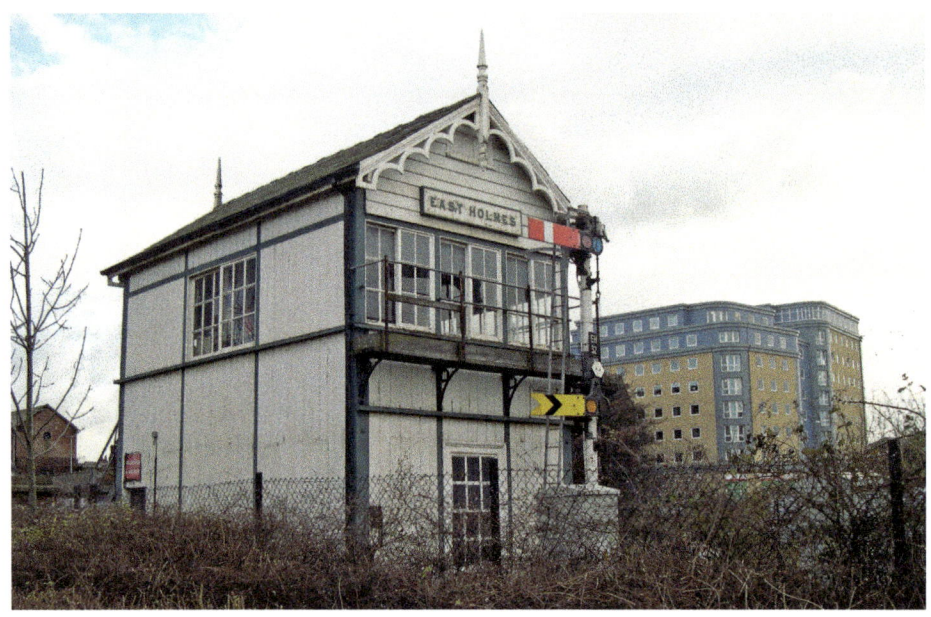

East Holmes signal box is the second oldest GNR structure in existence and is remarkable in that whilst others of a similar age have brick built lower floors, East Holmes was constructed entirely of wood – figure 12. The home signal in the front of the box is the up starter signal for trains going towards High Street with High Street's distant below it. February 2005.

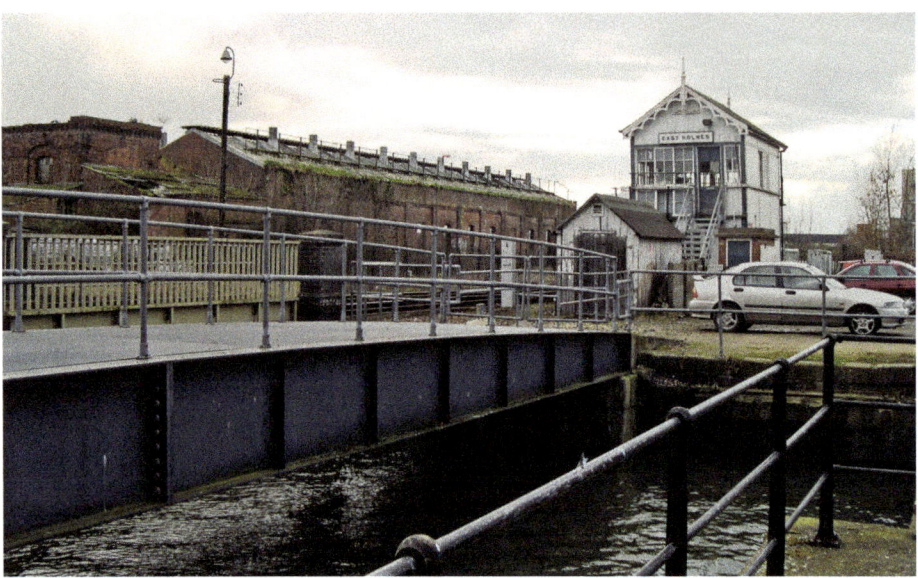

Figure 13 gives the lie of the land a bit better. The River Witham is in the foreground and the Brayford Wharf road and crossing is behind the camera.

The former steam locomotive depot, coded 40A under British Railways, is over the tracks opposite the box.

The view is looking towards West Holmes signal box. February 2005.

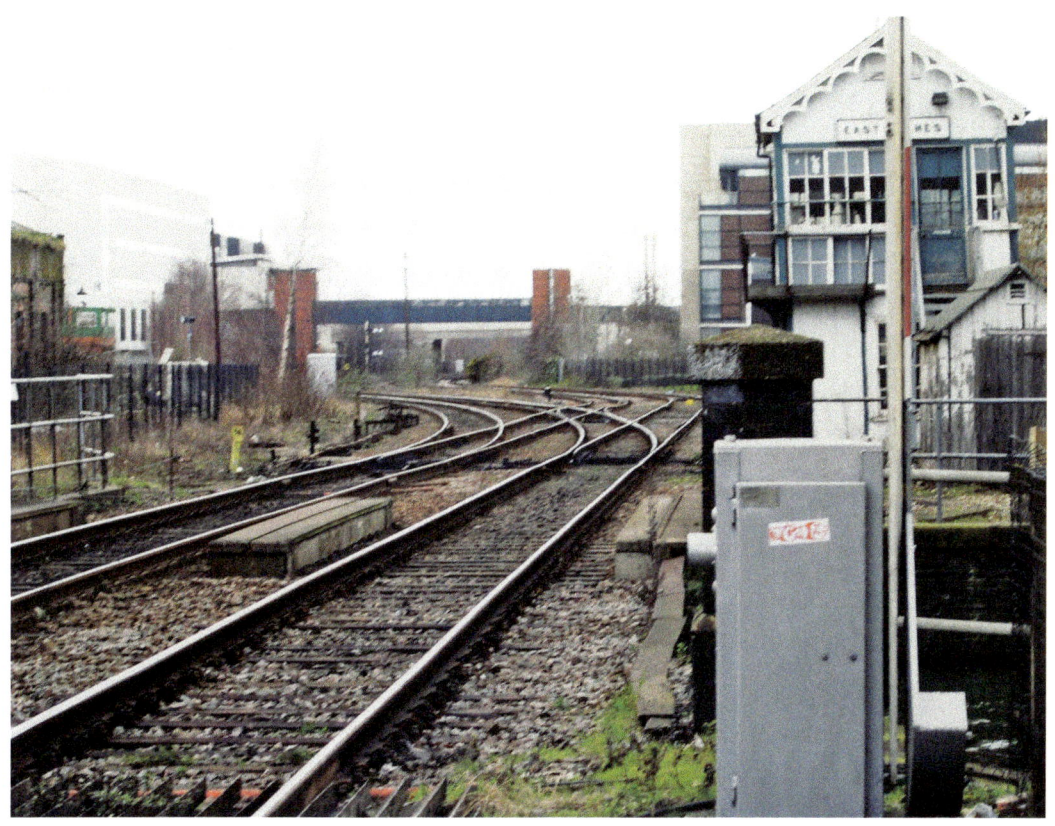

Figure 14 is the view from Brayford Road crossing. The River Witham is bridged and the Down main is on the left and the Up main is on the right. The two goods loops split off to the right. It may seem odd that the line of sharpest curvature and therefore lower speed is the main line whilst the goods loops would potentially be able to cope with higher speeds; Network Rail realised this too and changed the layout so that the goods loops are now the main running lines. At the end of the loops is West Holmes signal box.

Back to 2005 and the tracks then read, from left to right: Down main, Up main, Down goods loop, and furthest right Up goods loop. Note how the Up main crosses the connection to the Down goods loop with a single slip crossing; this is to enable a train to leave the Down goods loop and join the Up main line running towards the camera or a train on the Up main line to reverse into the Down goods loop. February 2005.

East Holmes signal box is 82 miles 60 chains (133.17 km) from Huntingdon South Junction via March.

West Holmes (WH)

Date Built	GNR Type or Builder	No. of Levers	Ways of Working	Current Status 2015	Listed Y/N
1882	GE-GN Type 2	69	AB	Closed 2008	N

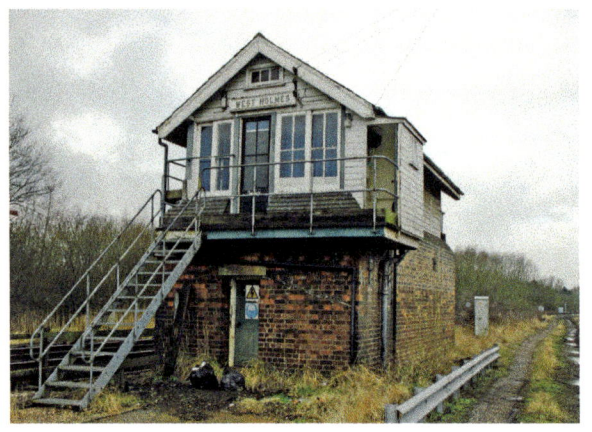

West Holmes is typical of those signal boxes that were thought to be vulnerable to blast damage through air raids in the Second World War and the massive brick ground floor reinforcement is basically a blast wall – figure 15. The view is towards Boultham Junction, where the Midland Railway line to Newark diverges. Further on from there Pyewipe Junction forms a leg of a triangular single track junction that can be seen on figure 3 just after West Holmes signal box. February 2007.

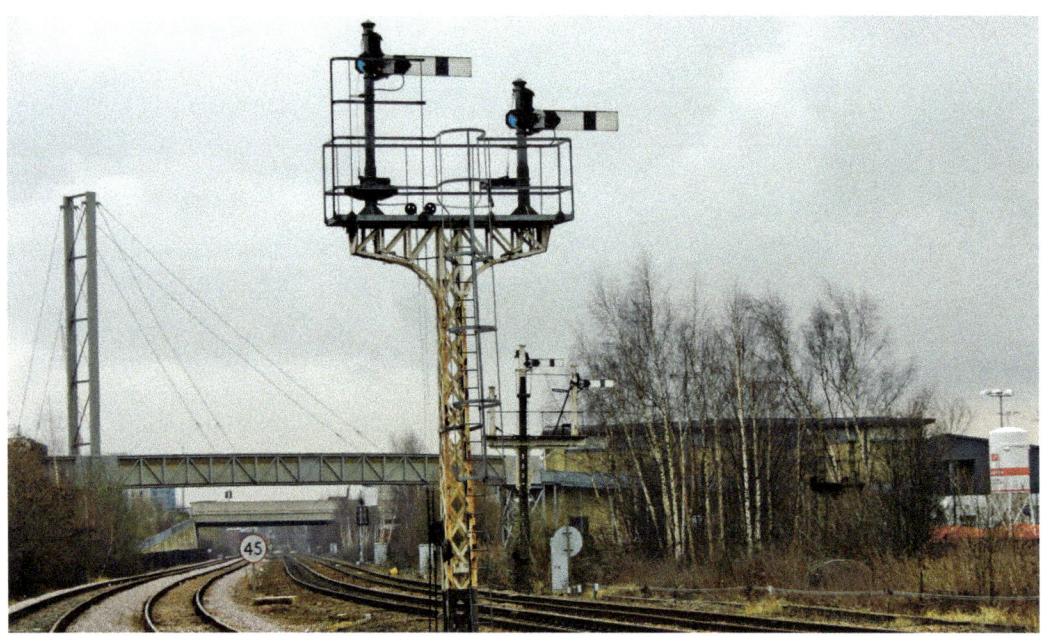

Figure 16 is a view back towards East Holmes and Lincoln station. The two bracket signals are to signal Down trains. The nearer lattice post is for the Down goods loop with a choice of the taller signal for the Gainsborough line, and the shorter for Newark. The concrete post signal with three dolls or posts similarly offers the Down main trains, and the shorter post without an arm gave access to a crossover to get to Holmes Goods Yard, which was behind West Holmes signal box. The Down main home signal before the bracket is just beyond the footbridge on the right of the tracks, complete with sighting board.

Those readers who have been to Specsavers will just be able to make out a home and distant signal on the same post just to the right of the 45 mph (72.42 km) speed restriction roundel sign. This is the same signal we saw in figure 14 in the piece about the East Holmes signal box.

Both bracket signals are thought to be LNER posts with more modern arms and dolls on them.

Just at the foot of the lattice post bracket signal is a two-railed trap point that works in conjunction with the Down goods loop exit point. A train in this loop would be facing the camera. Should the train driver set off before the points and signals are set, the train will be derailed by the trap point, and that is preferable to a collision on the main line. February 2007.

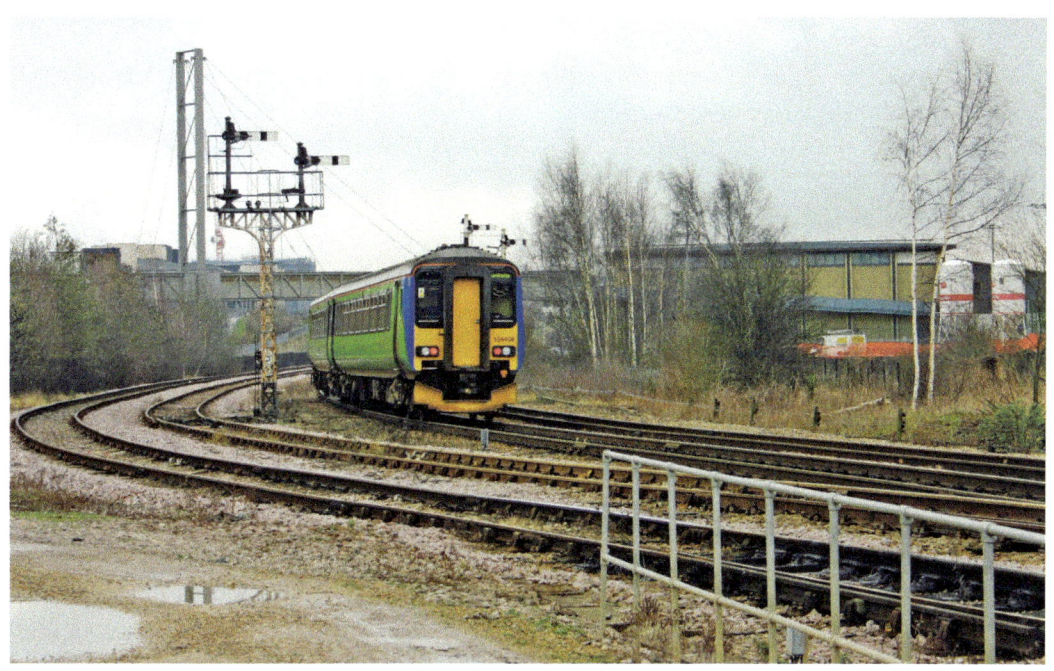

Figure 17 and Class 156, 156 408 is heading for Lincoln station. On the Up goods loop is a single-railed catch point, by the grey painted hand rail, and the purpose of this is to derail a train that has set back or reversed down the running line. In the Up loop the train would be facing away from the camera. Catch points would also derail a runaway vehicle, although this is now less likely as Network Rail stipulate that all vehicles must have automatically applied brakes if they are uncoupled from a train. Catch points can be spring loaded or 'worked' – that is to say driven by a lever from the signal box. These catch points appear to be spring loaded. February 2007.

Figure 18 is a look back at the goods loops and the way to Lincoln station. The new Lincoln Signalling Centre that replaces the function of all four boxes covered so far was built behind the box at West Holmes. February 2007.

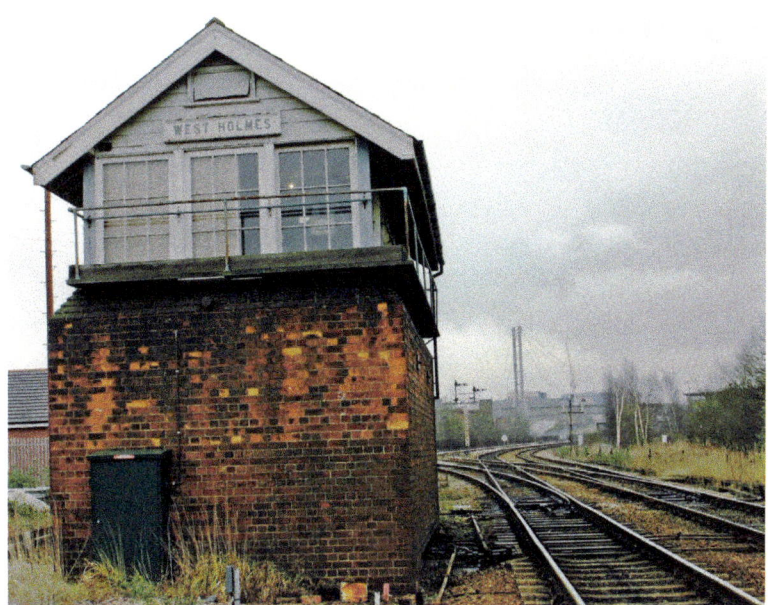

West Holmes is the first of the joint line signal boxes that were built in conjunction with the Great Eastern Railway. They are included in the GNR section because most of the block instruments and signalling kit was GNR and it seems geographically appropriate as well.

West Holmes signal box is 83 miles 29 chains (134.16 km) from Huntingdon South Junction via March.

Saxilby (–)

Date Built	GNR Type or Builder	No. of Levers	Ways of Working	Current Status 2015	Listed Y/N
1939	LNER Type 11b	30	AB	Demolished 2013	N

Saxilby is a large village that is by the Fossdyke Navigation Canal, an earlier form of communication with Roman origins. Saxilby has retained its station with ornate brick-built station building, and at the time of the survey still had wooden crossing gates, manually locked.

Saxilby station is 88 miles 51 chains (142.65 km) from Huntingdon South Junction via March.

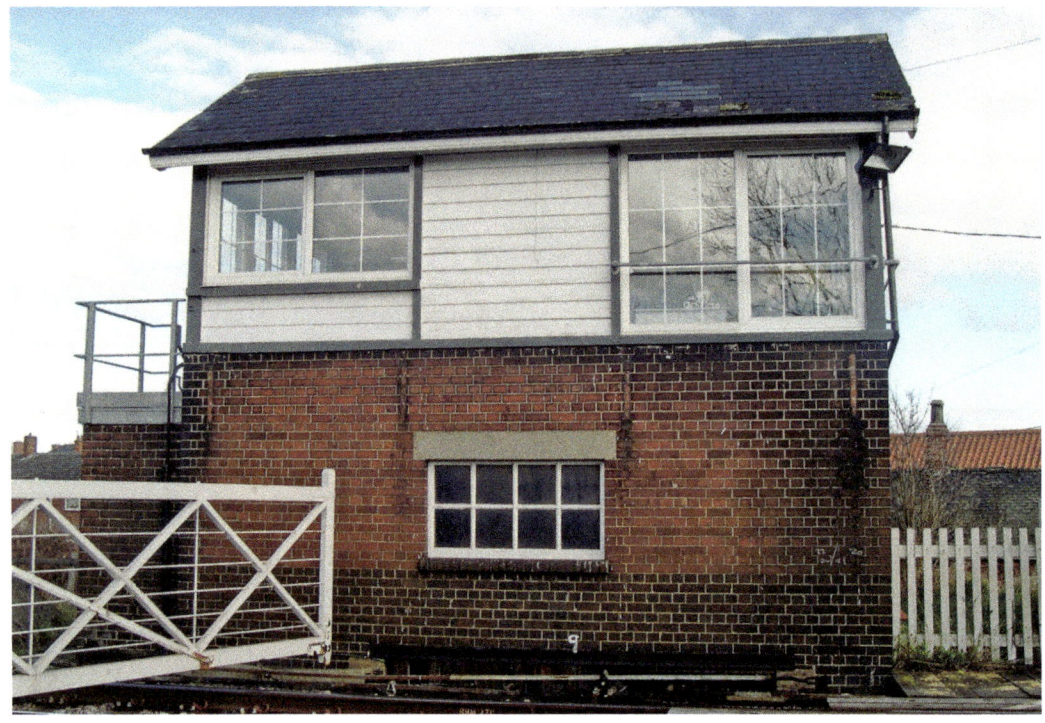

Saxilby signal box is at figure 19 and shows no signs of joint GE/GN ownership, although a letter from Network Rail in 2013 referred to the GEGN line and the box's demolition. Note the patch on the slate roof where the stove pipe would have been. Also note the crossing gate not locked in position, which is quite common in country areas where traffic is light on both sides of the track. The situation now is that the number of trains has doubled from fifty-six to 112 a day since the conversion to barriers. February 2005.

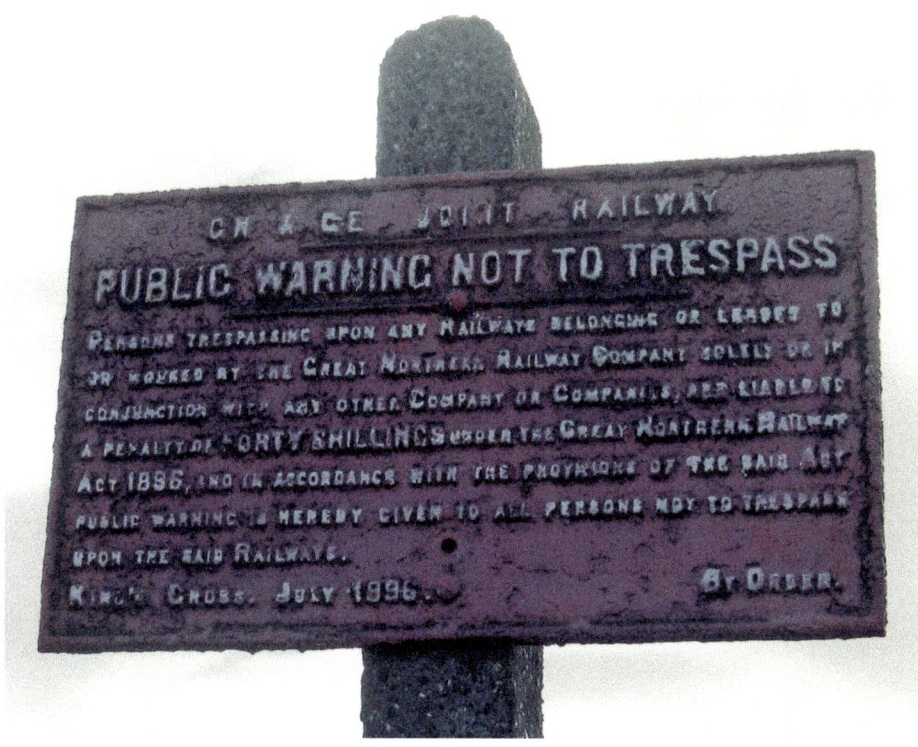

Figure 20 and back to the recent past with a joint line cast-iron trespasser notice by the crossing. In 1896, forty shillings would be well over a week's pay. February 2005.

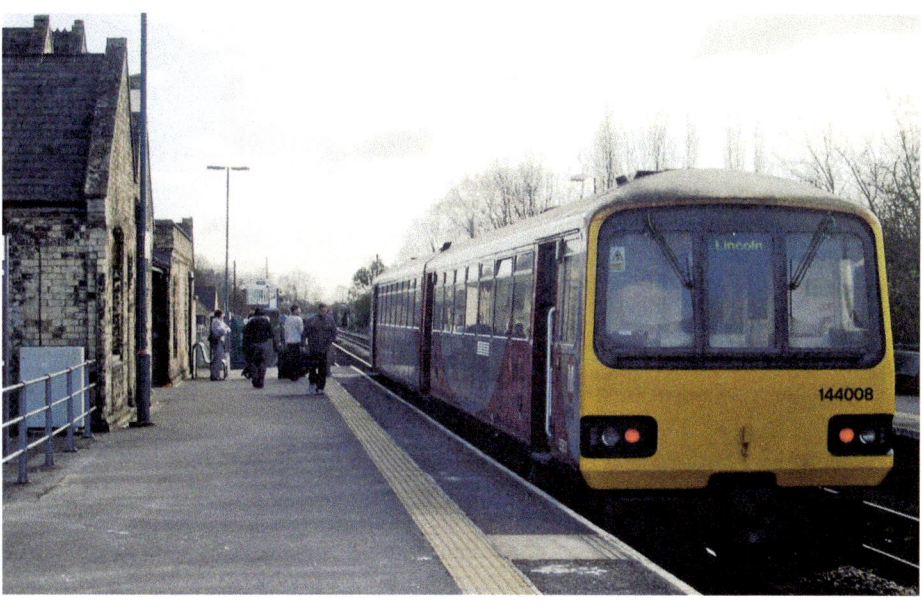

Figure 21 and Class 144, Pacer 144 008 disgorges passengers at Saxilby station while the box supervises in the background. The Pacer will continue its journey to Lincoln. February 2005.

Stow Park (SP)

Date Built	GNR Type or Builder	No. of Levers	Ways of Working	Current Status 2015	Listed Y/N
1877	GNR Type 1	32	AB	Closed	Y

Although still on the joint line Stow Park is a Great Northern box. Unlike Saxilby the station here closed in 1961, but the station building remains and is also listed. There is also a substantial GN-style goods shed, although it is no longer in railways use.

Stow Park signal box is 93 miles 13 chains (149.93 km) from Huntingdon South Junction via March.

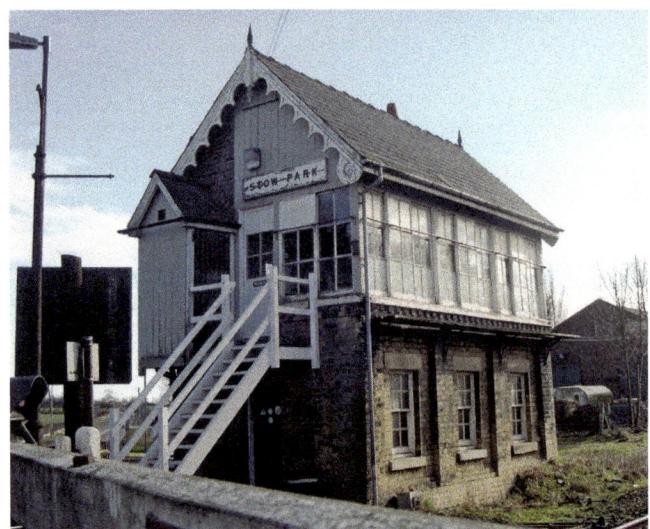

Apart from obvious replacement wooden steps, Stow Park signal box looks remarkably original, even down to the windows and chimney pot – figure 22. Note the cast-iron sign with its back to us, on the left, and the lamp standard in front of the electric light pole is of the type used to hang a pressurised paraffin or Tilley lamp on. Observe the GN goods shed in the background and how rainwater is collected from the tiny porch roof by cast-iron guttering. February 2005.

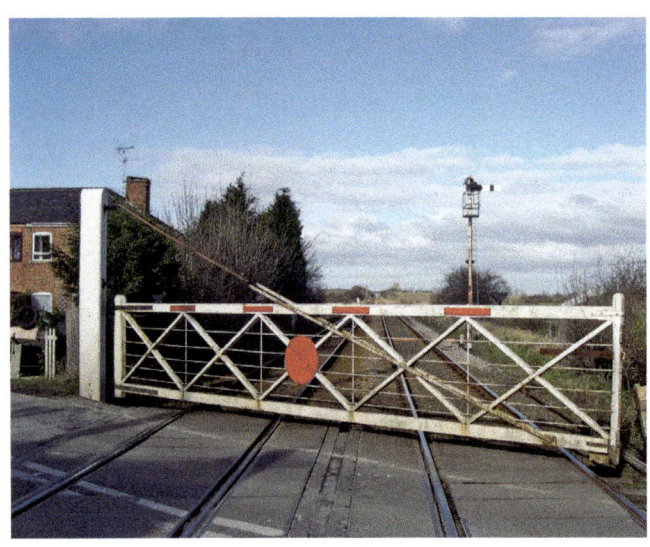

Figure 23 and once again the manually operated and mechanically locked gates are slightly ajar in the view towards Gainsborough. See the massive wooden post necessary to counteract the high leverage forces of the wide and heavy gates. Sometimes these posts are made of concrete. There is a pair of cottages on the left, which look as though they were for railway employees. February 2005.

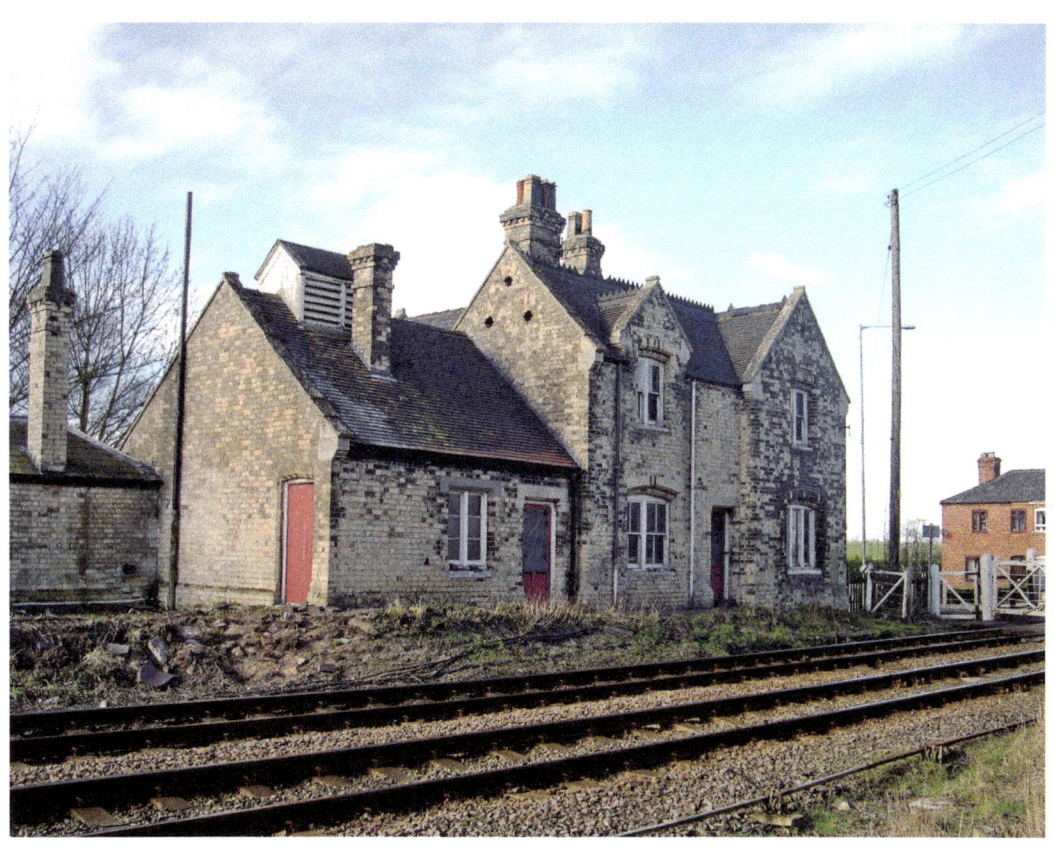

Figure 24 and the listed Stow Park station building is not as ornate as Saxilby, but has what looks like a provender store building on the side. The clerestory ventilator perched on top of the outhouse roof is typical of what was done to accommodate hay and straw within the building below and may have been used for railway horses. The point rodding in the foreground goes to the trailing crossover and both points are operated with a single lever in the signal box. Note the wicket gate for the crossing, which would be lever locked, and the station exit gate, which is not lever locked. February 2005.

Gainsborough Lea Road (LR)

Date Built	GNR Type or Builder	No. of Levers	Ways of Working	Current Status 2015	Listed Y/N
1877	GNR Type 1+	35	AB	Closed 2014	N

Gainsborough has been renowned as a port on the River Trent and much trade was conducted with Hull and inland. The town also had a considerable manufacturing base with industrial steam engines rather than locomotives. Gainsborough Model Railway Club is famous for their stupendous creation of the East Coast Main Line based around the 1950s, in O Gauge.

Gainsborough Lea Road station is 98 miles and 9 chains (157.86 km) from Huntingdon South Junction via March.

Gainsborough Lea Road signal box looks very smart in this 2005 view, but suffered a disastrous fire in 2009 and remained boarded up and out of use, although still on the books, until 2014 – figure 25. The view past the box is towards Stow Park and Lincoln. February 2005.

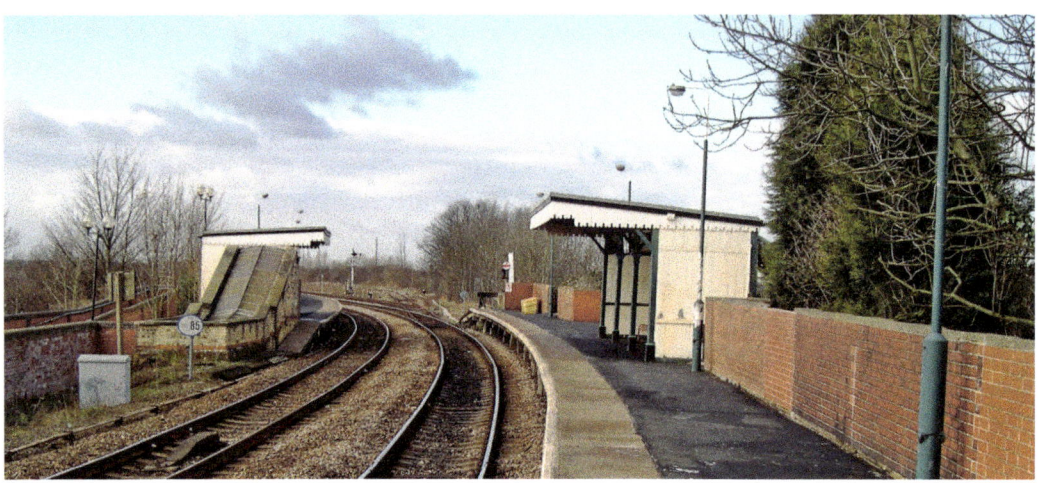

Figure 26. The station is built on raised ground and the station buildings are at street level some way below the platforms. There is a feeling in the town that the station is somewhat inconveniently situated, being twenty minutes' walk from the town centre. One of the staircase roofs can be made out on the Down left-hand platform. The line curves round to cross the River Trent and connect with the former Great Central lines to Doncaster and Sheffield. February 2005.

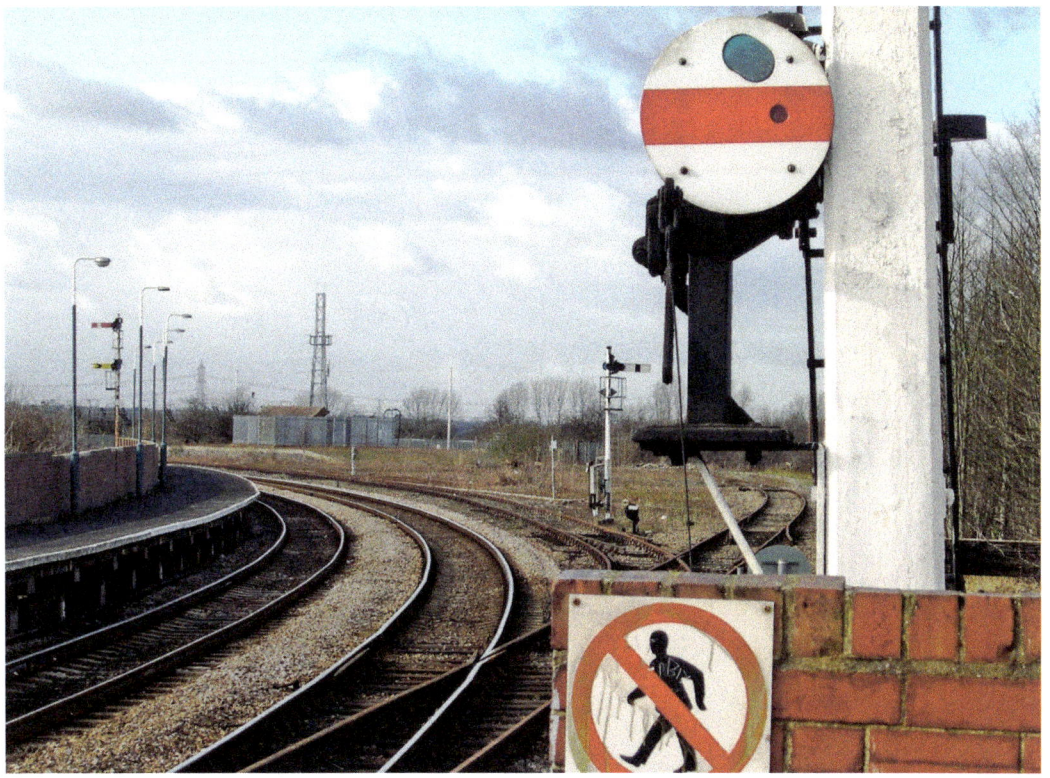

Figure 27. At the end of the Up platform at Gainsborough Lea Road is the oil terminal, though not showing any sign of recent use. The ground disc is for a reversing move from the Up platform into the oil terminal. The green aspect is larger than the red to allow for expansion of the signal wire in hot weather. Wire worked signals that are typically a mile (1.6 km) from the box usually have adjusters in the signal box to take up this expansion, which can be considerable.

The home signal and ground discs with their backs to us are the yard exit signals. Note both sidings have trap points leading off them.

The home signals on the left is the last semaphore before Trent East Junction signal box and the distant is likely to be Trent East Junction's as it is only about half a mile (0.8 km) to that box. February 2005.

Lincoln and Peterborough

This journey travels south through mainly flat, rich agricultural land through the towns of Sleaford and Spalding to Peterborough, and is another joint Great Eastern and Great Northern line. In the desire of Network Rail to create more routes for freight up the east coast, the line has been modernised since the survey, although some boxes survive as listed buildings.

The East Coast Main Line is seen to be 'maxed out' in terms of paths for extra trains and the routes through Lincolnshire were always popular diversionary routes. This was the case in steam days when the ECML was closed for engineering operations, mostly on Sundays.

This is part of the route that was originally built to bring coal from the Yorkshire coalfield to East Anglia at March.

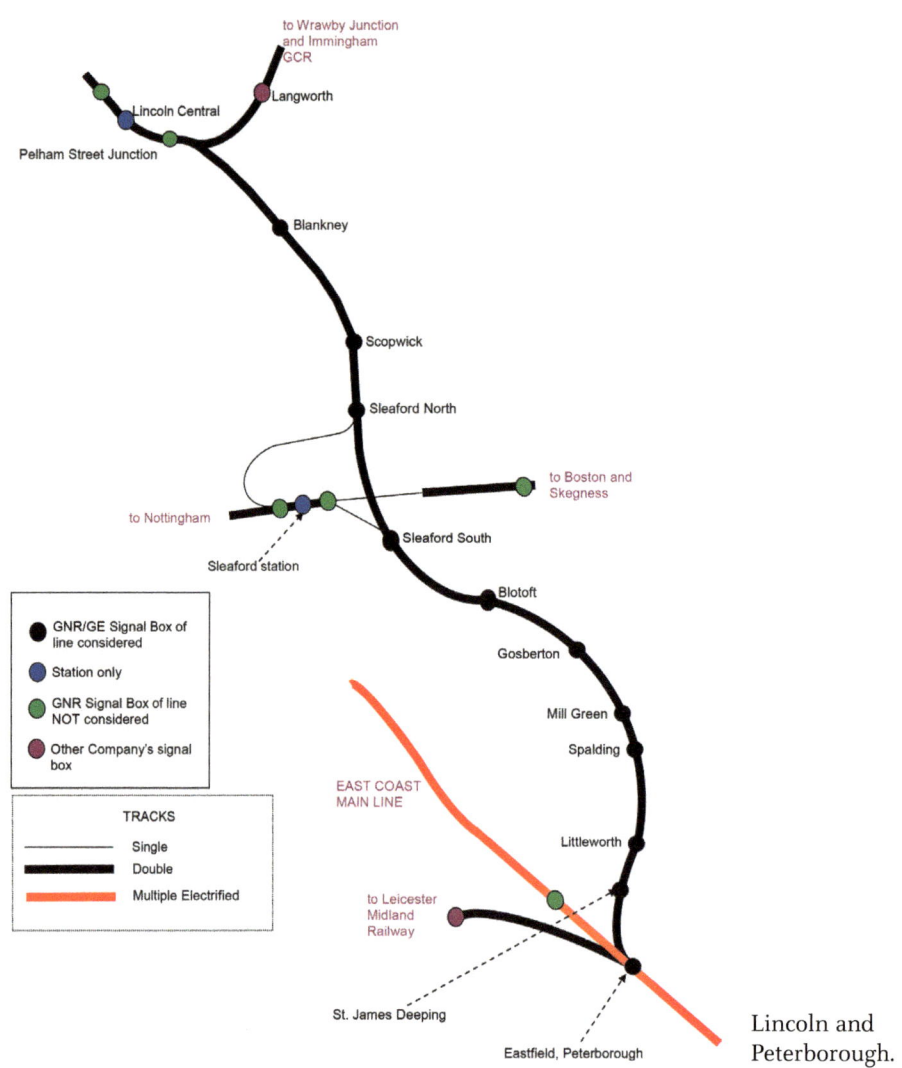

Blankney (–)

Date Built	GNR Type or Builder	No. of Levers	Ways of Working	Current Status 2015	Listed Y/N
1928	GNR Type 4b	30	AB	Closed 2014	N

Although the signal box retained the name Blankney, the station adjacent to the box is named Metheringham. The village dates back to Saxon times but is now mostly a dormitory village for Lincoln and the residents were successful in getting their station re-opened at a time when the trend was for closure all over the country. The station had closed in 1961 and was reopened in 1975.

Blankney signal box is 73 miles (117.48 km) from Huntingdon South Junction via March.

26

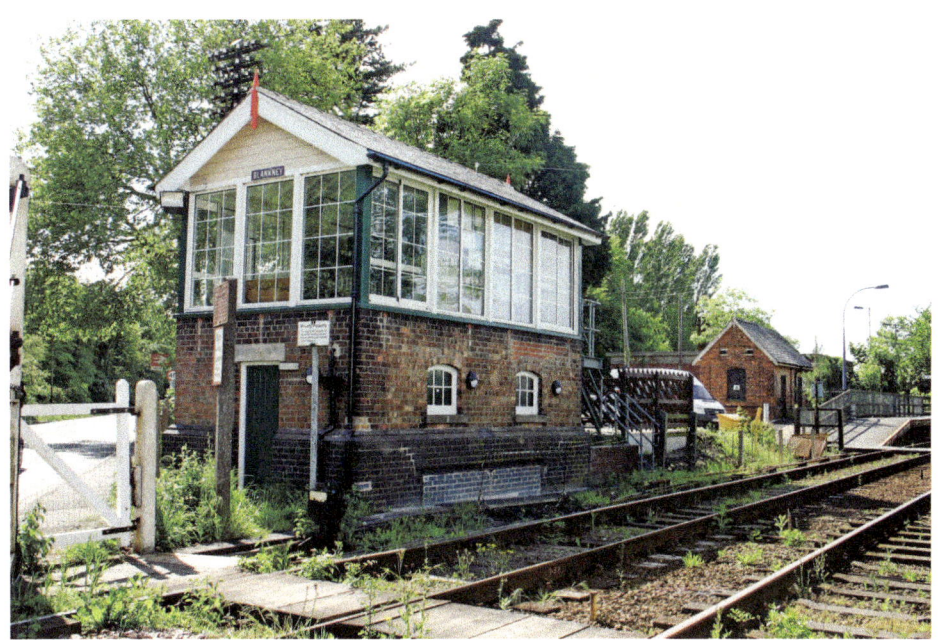

Figure 29 and the box looks in fine fettle, if a little over plasticised from the uPVC process. This box was built in LNER days but is of GNR design, as all the constituent companies carried on with their own designs until the LNER produced its own. The LNER also embarked, in the 1930s, upon a programme of introducing colour light signals, but this was mostly on main lines and at large stations. There is a cast-iron sign by the wicket gate but it is an LNER version, this time offering a fine or imprisonment for trespass, so inflation was present in the inter-war years. The modern platforms are on view but the brick built building behind the platform could be the original ticket office with the large window and ledge at this end.

At this time there were Down and Up refuge sidings here and the ground disc by the box with its back to us is to signal a reversing move into the Down siding. The small white arm on the rear of the signal is a backlight blinder and this serves to cover up a small light at the rear when the signal has been pulled off. This is used to indicate to the signaller that the signal has answered the lever; not as important here as the signal is right by the box, but vitally important if the signal is some distance away and with its back to the signaller and at night. May 2007.

Figure 30 shows Blankney signal box and the view is looking towards Peterborough. Note the crossing gate ajar once more and the mile post advising 73 miles (117.48 km). May 2007.

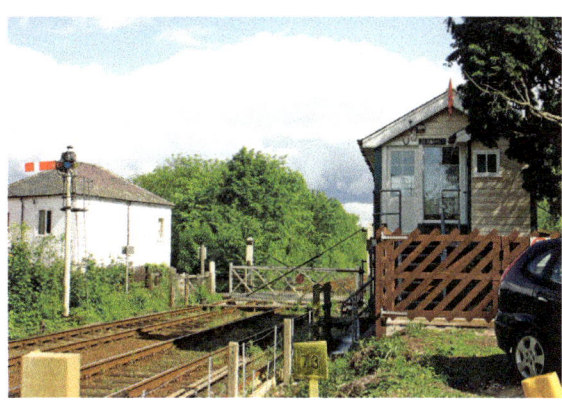

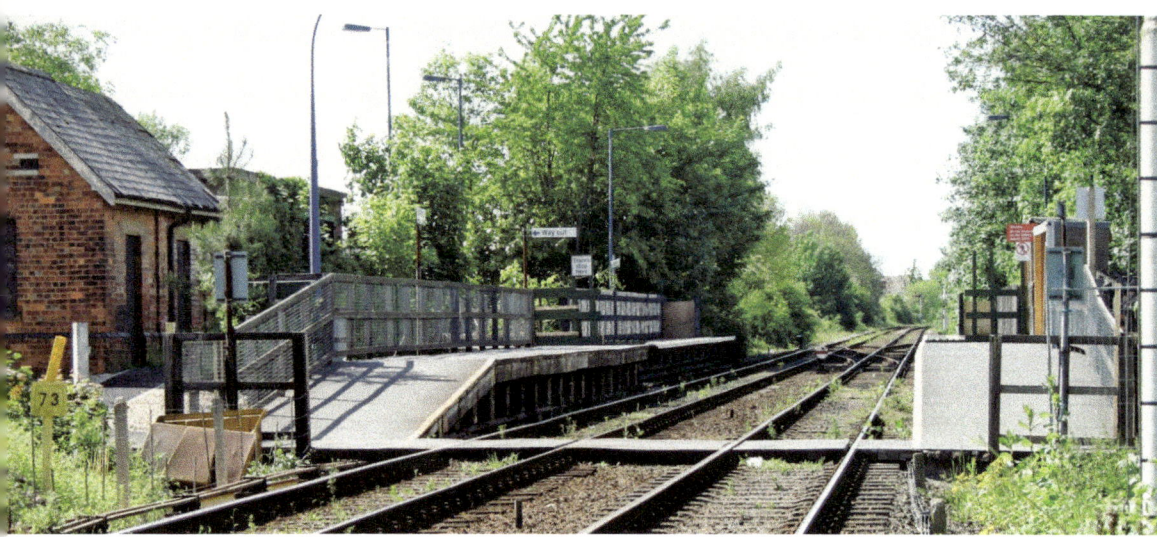

Figure 31 and the economy version 2 car DMU platforms of the reopened station and no footbridge. The trailing crossover has its ground disc facing a reversing move over it. The view is the one most commuters will get going the just over nine miles to Lincoln. May 2007.

Figure 32 and the Down refuge siding with exit ground disc and home signal protecting the crossing. Note the modern electric light on the gate only faces the road when the gates are closed. The gate itself is held horizontal by the steel strapping, which is adjusted by the screw turnbuckle. May 2007.

Scopwick (SK)

Date Built	GNR Type or Builder	No. of Levers	Ways of Working	Current Status 2015	Listed Y/N
1937	LNER Type 11a	25	AB	Demolished 2014	N

Scopwick is another small Lincolnshire village that has associations with the RAF during the Second World War, and there is a Commonwealth War Graves site in the village cemetery.

Scopwick signal box was 70 miles and 48 chains (113.62 km) from Huntingdon South Junction via March.

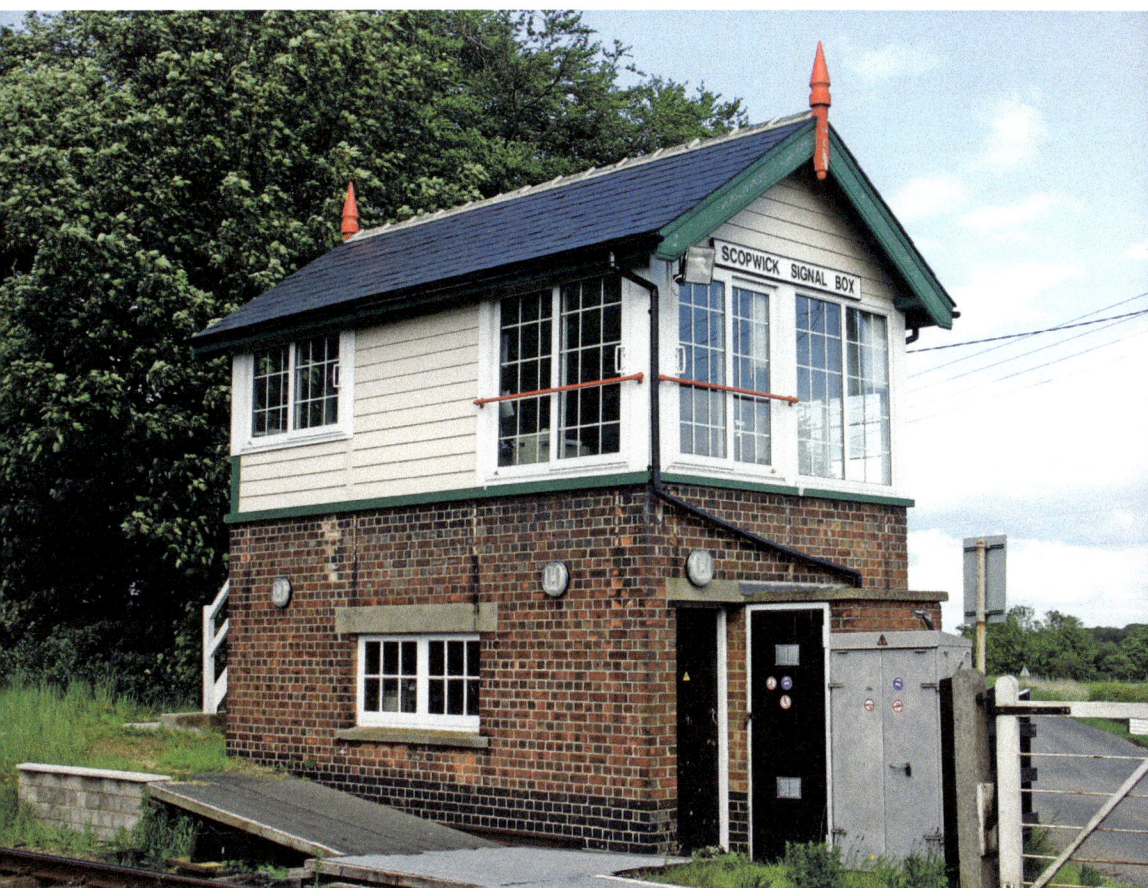

The signal box at Scopwick was remarkable in that it controlled four crossing gates by use of a complicated set of levers and a gate wheel inside the box – figure 33. This mechanism was lever locked and these levers were interlocked with signals such that no signals could be pulled off if the gates were closed across the track.

The four gates were needed as the road crosses the tracks at an angle that is not right. May 2007.

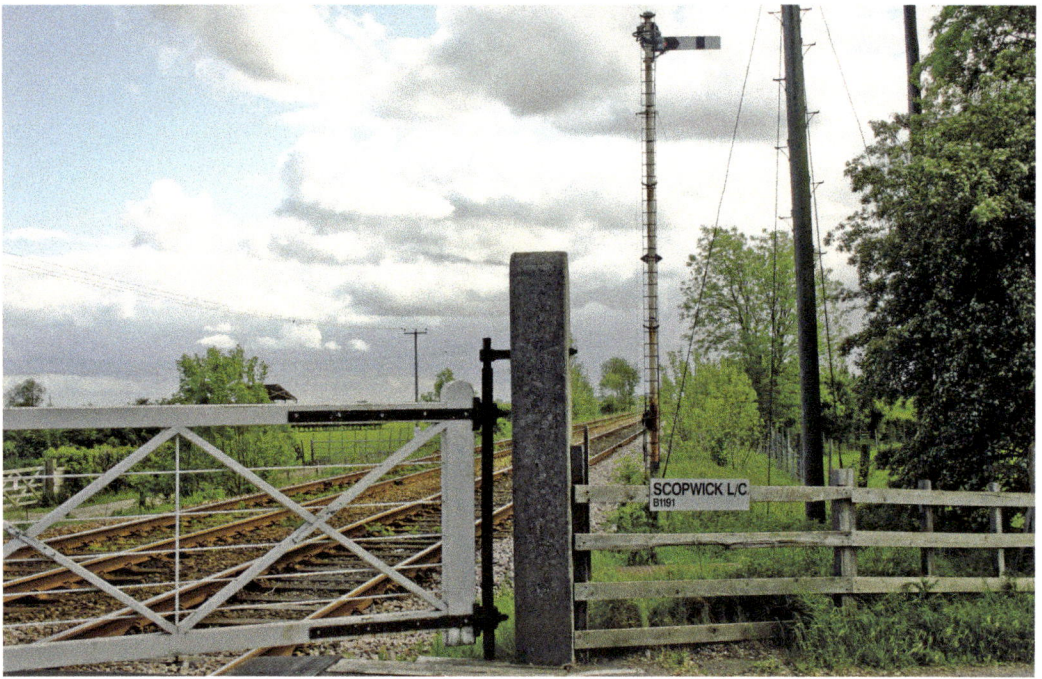

Figure 34 and the black rod on which this gate pivots disappears under the road and is connected to the box and the other three gates by a mechanical linkage. The fairly clever part of this is that the linkages have to be arranged so that the gates, which all travel different distances, both open and close at roughly the same rates, so that they lock together. Note the telegraph pole by the signal post with stacks of insulators for analogue telephone wires. The view is looking towards Peterborough. May 2007.

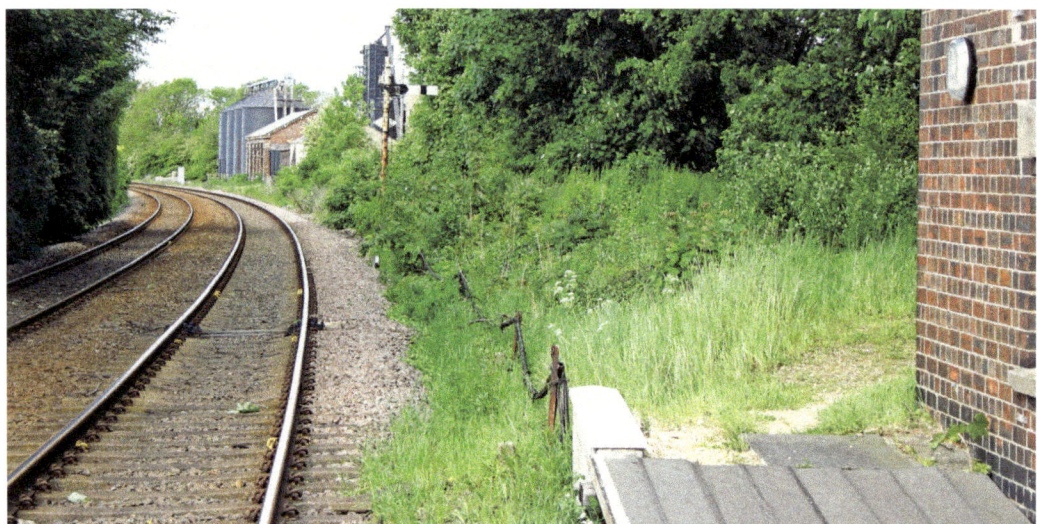

Figure 35 and the view towards Lincoln past the site of the station and the goods shed is lurking in the undergrowth on the same side as the box. The station site is now occupied by a plant nursery. May 2007.

Sleaford North (SN)

Date Built	GNR Type or Builder	No. of Levers	Ways of Working	Current Status 2015	Listed Y/N
1882	GE Type 2	25	AB	Closed 2014	N

Sleaford is an attractive market town centred on agriculture that became a hub for railways from an early date and was the last place in Britain to have signal boxes named north, south, east, and west. It is also closely associated with RAF College Cranwell nearby, which had its own branch line that was finally closed in 1956.

Sleaford North signal box is 64 miles and 48 chains (102.35 km) from Huntingdon South Junction via March.

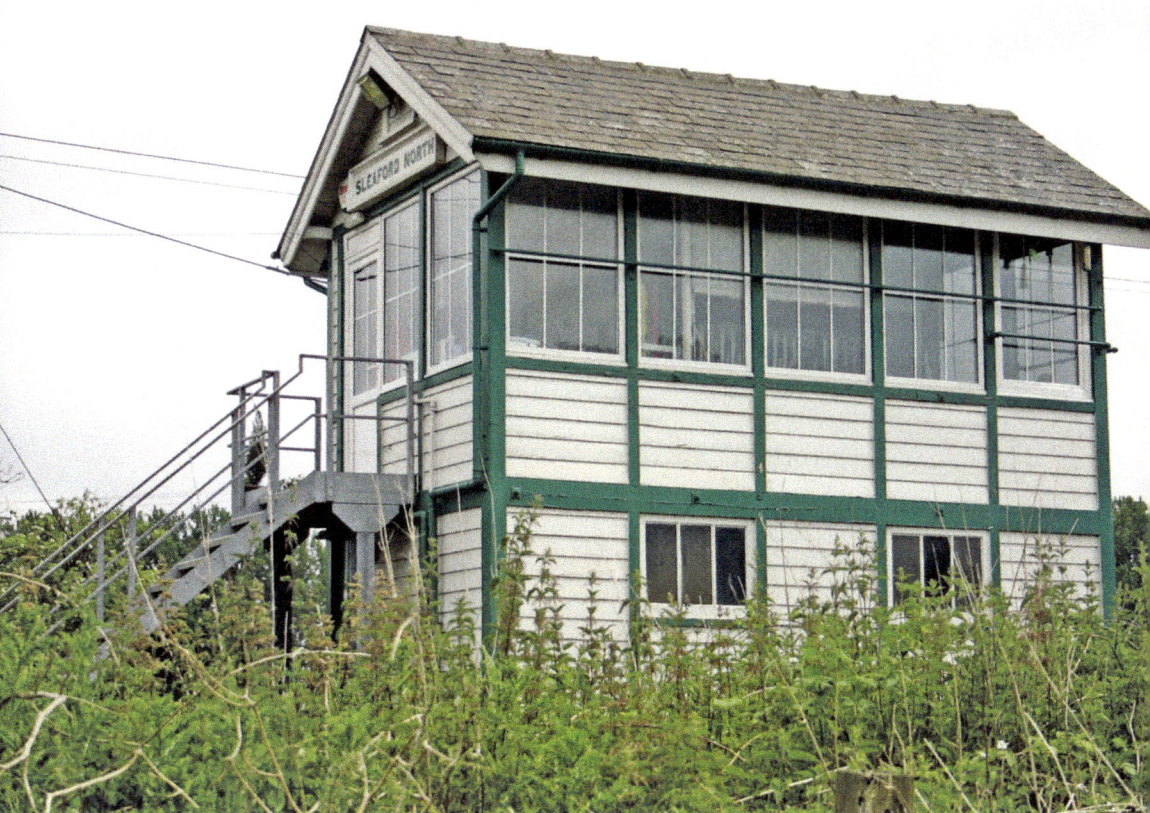

Sleaford North is the first Great Eastern box on this joint line, as well as being a block post, and is the junction for a single loop line to Sleaford West and a connection to the Nottingham to Skegness line and Sleaford station.

Timber-framed signal boxes were popular on the Midland Railway and some have lasted 130 years and so it is here, albeit modernised with new windows and steps – figure 36. February 2005.

Figure 37 and the junction to Sleaford West signal box and the station curves away to the right of the picture. Originally two curving tracks came in, one of which crossed the Down right-hand running line with a diamond crossing. The line to Sleaford South runs to the top left of the picture. There is a facing crossover to the right out of shot that permits trains on the Up left-hand line to access the loop line to Sleaford West. February 2005.

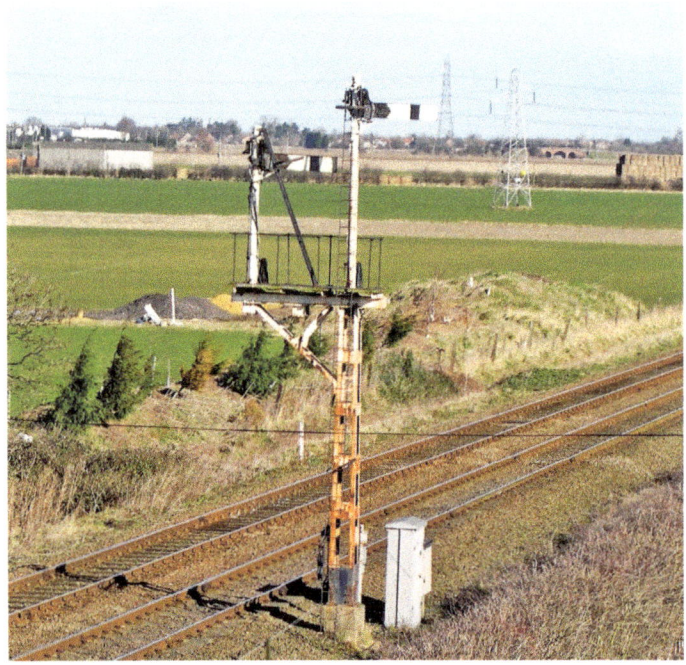

Figure 38 is the opposite view up the line towards Lincoln. The bracket signal is for the junction we have just seen on the previous figure. However, it was a feature of the signal interlocking that the distant signal along the line, warning of the bracket signal, on or at caution, could not be pulled off. February 2005.

Sleaford South (SS)

Date Built	GNR Type or Builder	No. of Levers	Ways of Working	Current Status 2015	Listed Y/N
1957	BR Eastern Region Type 16a	25	AB	Closed 2014	N

Sleaford South signal box was among the asparagus fields in a very rural location.

Sleaford South signal box is 62 miles and 13 chains (100.04 km) from Huntingdon South Junction via March.

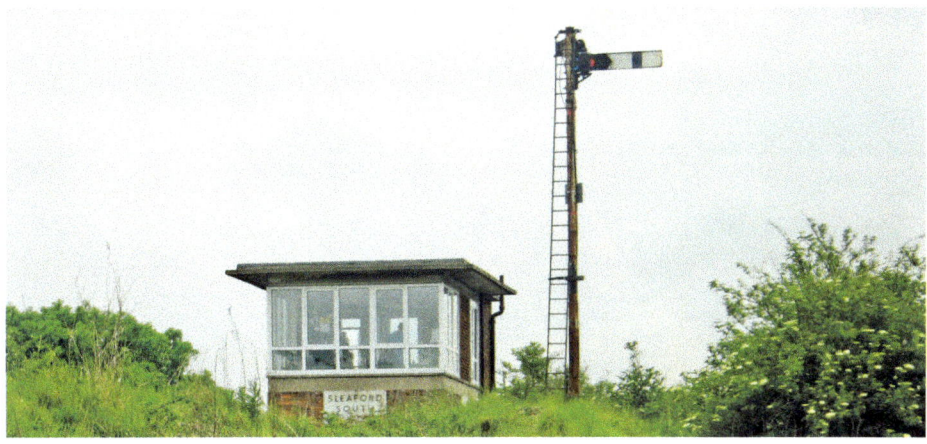

Fig. 39. The lesser-spotted Sleaford South signal box is a modern replacement for an 1882 structure and has been traumatised by a derailment. In October 1965 at 3:15 a.m. a fitted or fully braked freight from March in Cambridgeshire to Manchester derailed south of the box. When it got to the junction points, about fifteen of the thirty wagons in the train were deflected across the junction, some of which hit the rear of the box. The view is looking north and the tracks pass either side of the box. May 2007.

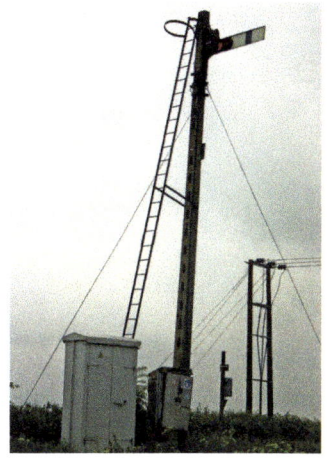

Figure 40 and an LNER concrete posted home section signal with modern arm guarding the route south to Blotoft and Peterborough. May 2007.

Blotoft (BT)

Date Built	GNR Type or Builder	No. of Levers	Ways of Working	Current Status 2015	Listed Y/N
circa 1882	GE Type 2	16	AB	Demolished 2014	N

Blotoft had been an original GE wooden signal box, but had been so altered during the modernisation in 2002 that its appearance was changed quite markedly. This no doubt had a bearing on listing considerations and the box was demolished soon after closure.

Blotoft signal box was 55 miles and 25 chains (89.02 km) from Huntingdon South Junction via March.

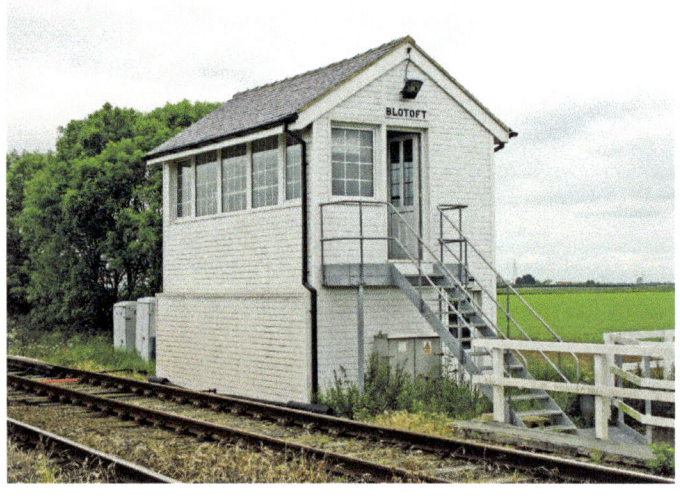

Blotoft signal box. The Lincolnshire fens stretch for miles and the countryside round here is often referred to as 'Big Sky' – figure 41. May 2007.

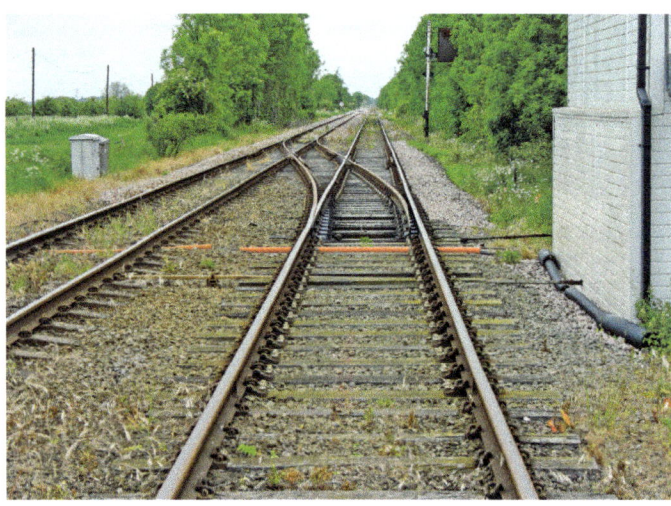

Figure 42 and the flatness of the terrain is emphasised with the view towards Sleaford South and the trailing crossover. The section home signal protecting the crossover and crossing behind the camera appears to have been lowered on the post. This is a fairly recent innovation from the 1990s, where any signal that could be lowered was, on health and safety grounds. May 2007.

34

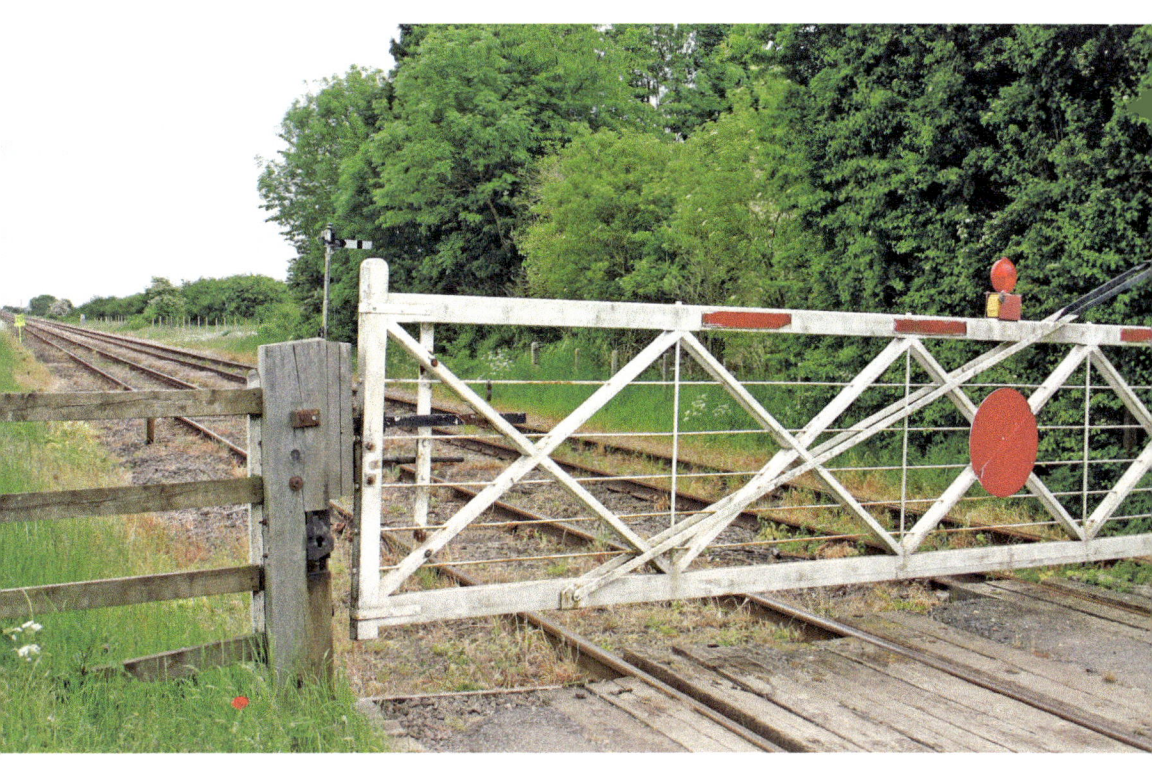

Figure 43 and the manually operated gates, which are lever locked. The locking lever is interlocked with the signal lever such that the section signal cannot be pulled off unless the gates are locked in the closed against the road position. All these manual and wheel operated crossings on the route have been replaced by automatic barriers. May 2007.

Gosberton (GO)

Date Built	GNR Type or Builder	No. of Levers	Ways of Working	Current Status 2015	Listed Y/N
circa 1882	GE Type 2	30	AB	Demolished 2012	N

Gosberton is mostly an agricultural community but there are significant numbers of commuters to Boston and Spalding, just not by rail.

Gosberton signal box was 49 miles and 13 chains (79.12 km) from Huntingdon South Junction via March and Gosberton 100 crossing was 49 miles and 26 chains (79.38 km) from the same datum point.

Gosberton signal box looks as though it is original in figure 44 and is unusual in that it does not have a crossing outside the box, only a crossover. It did supervise Gosberton 100 crossing, which was located 13 chains (261 m) down the line. The two structures were interlocked electrically, such that gates could not be opened if the signals were off for a train on either Up or Down lines, and gates had to be closed off against the road before signals could be pulled off. May 2007.

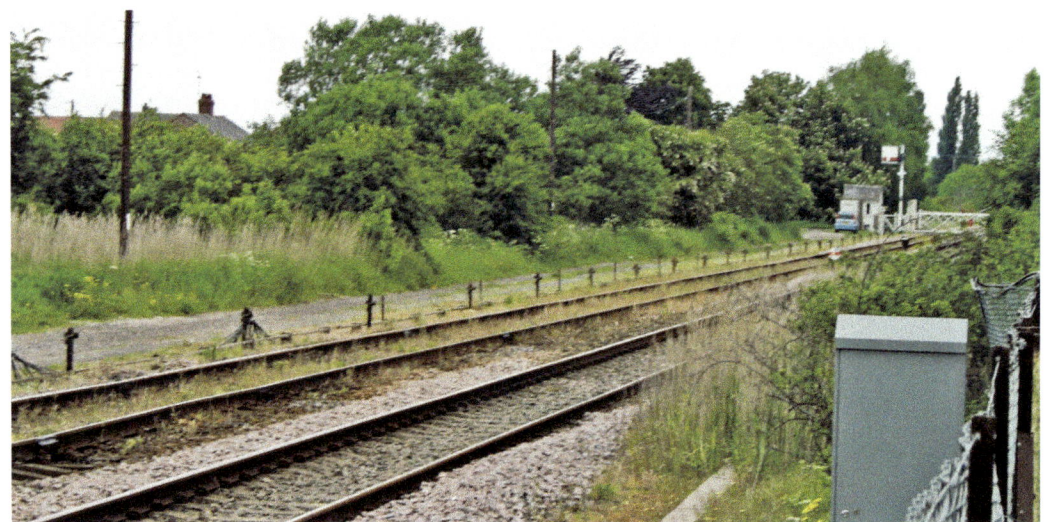

Figure 45 is Gosberton 100 crossing in the distance and the separate signaller's car outside by the manual crossing gates. The box is across the tracks from the camera. May 2007.

36

Figure 46 is Gosberton 100 crossing hut. The lever frame outside has only one active lever and a gate lock in the blue/brown colours. The indicator in the wooden box above the frame reads 'FREE', with the other indication being 'LOCKED'; clearly the action of pulling over the lever is to unlock the gates.

The electric bell on the hut side by the window is to summon the crossing keeper and is operated by the signaller in Gosberton signal box. May 2007.

Figure 47 is inside Gosberton 100 crossing hut and the indicators shown are a subset of the Gosberton signal box's absolute block instruments, and this informs the crossing keeper of a train's imminent approach. The Up line towards Peterborough has a customer who is not quite there yet, but nothing doing on the Down towards Lincoln. May 2007.

37

Figure 48 is looking back up the line towards Peterborough and Gosberton signal box on the same side as the hut in the distance. May 2007.

Mill Green (MG)

Date Built	GNR Type or Builder	No. of Levers	Ways of Working	Current Status 2015	Listed Y/N
1882	GE Type 2	21	AB, TCB	Demolished 2014	N

Mill Green is near Spalding, which had been modernised, and so no mechanical signals were here at the survey date.

Mill Green signal box was 44 miles 74 chains (72.30 km) from Huntingdon South Junction via March.

38

Mill Green signal box. It did have a gate wheel to drive the crossing gates from the box – figure 49. May 2007.

Figure 50 and inside Mill Green signal box and the gate wheel is centre stage. This particular one was built by Railway Signalling Company in Liverpool but the railway companies built their own at later dates. The gate wheel, when spun rapidly, develops a flywheel effect and takes some stopping. The lever is to apply a brake, but before a considerable momentum could be built up the gate lock levers would need to be released. The gate lock levers are the brown levers in the frame, numbers 19, 20, and 21. Note that levers 20 and 21 have stop reminders on them, which is usually to remind the signaller that a particular function is being worked on, and this was the case on the survey date. May 2007.

39

Figure 51 and the signalling diagram and block shelf at Mill Green. The line is clearly under engineer's possession at present as both ends of the diagram have 'Line Blocked' marker labels on them. The box is depicted below the running lines underneath the ILL of the MILL GREEN label. The crossing gates straddle the running lines by the box. The double red lights are track circuit indicators and if a train were on a particular circuit, both lights in a pair would be lit. The black rectangular boxes screwed to the blockshelf are signal status indicators and they are showing the current aspect of a particular signal.

The two on display are, right to left, distant at caution and home signal at danger.

The black and white instrument on the block shelf is a BR standard 'domino' absolute block instrument. It is the instrument to communicate with Gosberton signal box. There is only one as the box works TCB to Spalding. At the bottom of the unit is a block bell and tapper key. If the tapper key is operated it rings the bell on the block instrument at Gosberton. If the bell rings here it is Gosberton that has operated it.

Above that is the block status for a train going from Gosberton to Mill Green, Up line. When Gosberton offers a train it must be accepted at Mill Green and the dial turned to *Line Clear*. When the train approaching Mill Green has left Gosberton's section, this is belled two beats and the lever at Mill Green is set to *Train on Line*. When the train passes Mill Green to the next section at Spalding the dial is set to Normal or Line Blocked, and the next train from Gosberton can be sent. When a train is passing on the Down line to Gosberton it is the signaller at Gosberton who must set their instrument to *Line Clear,* and that status is reflected on the upper dial at Mill Green and so forth as before.

The circular device with the cranking handle below the domino block instrument is a Welwyn Control release. In 1935 at Welwyn Garden City on the Great Northern line out of King's Cross a collision occurred that was to change railway operating practice. A signaller had accepted a train into the station, which was at a stand at the platform. The signaller then gave *Line Clear* on the block instrument for a following train, which crashed into the stationary train with much loss of life and injury. The outcome of this was that not only were points and signals interlocked, but block instruments were interlocked with track circuits such that it would be impossible to give *Line Clear* if the track circuit detected a train already in the destination section. The Welwyn Control release is an override but incorporates a timer to ensure nothing happens without due care.

The other square grey box screwed to the block shelf is a barrier control for a crossing; there were two such panels here. May 2007.

Figure 52 is the Spalding end of the frame to which Mill Green worked Track Circuit Block. In addition to there being no AB instrument for this section, there is only one multiple aspect colour light signal in lever 3, and the only other lever is lever 1 – a gate lock. The white stripe on lever 2 is to signify that there is an electrical lock that has to be released before this signal can be cleared or pulled off. The rest at this end are white and date back to all AB days. The other essential equipment here is the signaller's armchair and microwave cooker. May 2007.

Spalding (SG)

Date Built	GNR Type or Builder	No. of Levers	Ways of Working	Current Status 2015	Listed Y/N
1921	GN Type 4b+	IFS Panel	TCB	Demolished 2014	N

Spalding has its roots in agriculture.

Spalding signal box was originally Spalding No. 1 and there were several signal boxes here.

Spalding station is 44 miles 26 chains (71.33 km) from Huntingdon South Junction via March.

Figure 53 and back in Great Northern territory. The usual shot of Spalding box is to the front, but as it didn't have any more windows than the rear, perhaps this is more interesting. The chimney stack is long out of use, but a fine execution in brick. The tacked-on admin block is also visible. The box also supervises a road crossing at this time and this seems to be common for Lincolnshire signal boxes.

The box was equipped with an Individual Function Switch or IFS panel that presents the signaller with point and signal switches laid out in diagrammatic form and each switch must be operated as if they were levers; interlocking is by electrical relays rather than a mechanical frame. May 2007.

Figure 54 is Spalding station looking towards Sleaford and Lincoln, and whilst the box only controlled a couple of crossovers and three sidings, it is possible to get an idea of the size and importance of the layout from this picture.

The train service was not intensive at this time judging by the inebriated reveller on the rail by the platform. May 2007.

Littleworth (–)

Date Built	GNR Type or Builder	No. of Levers	Ways of Working	Current Status 2015	Listed Y/N
1875	GN Type 1+	30	AB	Closed Extant Apr 2015	N

Littleworth signal box is in the village of Deeping St Nicholas.

The mileage changes just after the crossing at Spalding and Littleworth signal box was 87 miles 61 chains (141.24 km) from King's Cross via Peterborough.

Fig. 55 and the box is alongside the former station whose building has survived and goods shed in agricultural use. Despite uPVC windows there are many fine GN features remaining; the scalloped barge boards, chimney stack, wooden staircase, locking frame windows and slate roof complete the period scene. The former station building is to the left. May 2007.

Fig. 56, where the view is towards Spalding, and there are no points here and electrically operated barriers. The box is basically a block section with crossing. May 2007.

43

Fig. 57 and the view is towards Peterborough and the station building along from the box. The section signal is off. May 2007.

St James Deeping (SD)

Date Built	GNR Type or Builder	No. of Levers	Ways of Working	Current Status 2015	Listed Y/N
1876	GN Type 1+	32	AB	Closed and Moved	N

St James Deeping signal box's demolition was the subject of a protest by local people who succeeded in having the box removed to within the village.

St James Deeping signal box was 83 miles 38 chains (134.34 km) from King's Cross via Peterborough.

The line joins the East Coast Main Line at Wherrington Junction and heads south to Peterborough.

Fig. 58 is St James Deeping signal box and the fact that it is a mostly brick structure makes removal and storage that much more difficult. There are manual crossing gates here at the survey date and no gate wheel, just the hand to open and close. May 2007.

Figure 59 and the view is towards Littleworth, with a modernised section home signal on the Up towards Peterborough and a colour light on the Down towards Spalding. On the other side are the remains of the station building and a trailing crossover. May 2007.

Figure 60 and the rear of St James Deeping signal box, most unusually with rendered brickwork. The box has its own post box and this was quite common where no other suitable location existed. May 2007.

Eastfield (–)

Date Built	GNR Type or Builder	No. of Levers	Ways of Working	Current Status 2015	Listed Y/N
1893	GN Type 1+	63	Shunt Frame	Active	Y

Peterborough has long been known as a hub of the fenlands of East Anglia. Peterborough has a long history and a fine cathedral, although the town is more associated with a go-ahead aspect than an historical one. The ECML journey was decorated with the works of the London Brick Company at Fletton. As well as being the junction for East Anglian lines, Peterborough also has a connection with the Midland Railway to Syston in Leicestershire.

Of the scores of Great Northern signal boxes on the ECML, this is the only survivor with mechanical signalling, which lives inside Peterborough's marshalling yard.

Eastfield signal box is 77 miles and 2 chains (123.96 km) from King's Cross.

Fig. 61 and Eastfield signal box is in a time warp next to the ECML. Indeed, across the road from the box, behind the camera, are the six brand new stabling sidings for Thameslink trains. The sidings are on the site of the New England steam sheds that saw Gresley Pacifics, as well as freight locomotives. April 2015.

Fig. 62 and a pair of yard exit signals, which both give an option for separate destination roads. The signal lower down the post is for a road to the right of the locomotive and the upper for one to the left. There are other signals in the yard and one under the wires, which is unusual. The concrete-posted signal is of LNER vintage. April 2015.

Nottingham to Skegness

There will be many who will remember the journey as an eagerly excited child setting off for a day at the seaside. This was one of the principal holiday routes to Skegness, but there were others that joined this route from Leicester, Sheffield, and Derby. This GN route does not start from its original destination of Nottingham Victoria, as that was closed and pulled down, and is now a retail destination.

Nottingham is famous as the lace-making capital of Britain and names like Boots, John Player, and Raleigh cycles serve to underpin the industrial structure of the city. The city was also surrounded by coal mines.

The schematic diagram at Fig. 63 starts at Netherfield Junction in the heart of the former coal mining area and runs through ever-more rural countryside to Sleaford. The line sets off again, single track, and reaches the inland port of Boston. The line then heads north by the Wash for the coastal town of Skegness.

Nottingham to Skegness.

Netherfield Junction (NJ)

Date Built	GNR Type or Builder	No. of Levers	Ways of Working	Current Status 2015	Listed Y/N
1960	BR Eastern Region Non Standard	40	AB	Closed 2013	N

Netherfield Junction is actually the place where the Great Northern lines diverge from the Midland, which makes its way to Lincoln via Newark.

The box is 27 chains (543 metres) from the actual junction tracks and round a sharp curve.

The massive Colwick locomotive depot was not far away. Gedling colliery nearby was producing about a million tons of coal a year at this time.

Netherfield Junction station is 125 miles 13 chains (201.43 km) from King's Cross.

Figure 64 shows a signal box that was confidently looking forward in 1960 to many more years of coal production in the area, and steam locomotives chuffing past the box hauling the coal. February 2007.

49

Figure 65 is the view towards the actual junction and the signal box and two platforms of Netherfield Station are in the space between the running lines. The crossover is to allow trains to cross from the left-hand Down running line to the former Gedling colliery. February 2007.

Figure 66 and the view towards Sleaford and Skegness as the lines curve away to the right. Gedling colliery was renowned, not only for its productivity figures, but as a kind of United Nations of coal mining where miners had come from many different countries to win the coal. February 2007.

Rectory Junction (RJ)

Date Built	GNR Type or Builder	No. of Levers	Ways of Working	Current Status 2015	Listed Y/N
1888	GN Type 1+	42	AB	Closed 2013	N

Rectory Junction is a junction but of freight-only lines, apart from the two main lines. The Colwick oil terminal is a major distribution centre for the East Midlands and it receives its supplies by pipeline from Lindsey in Lincolnshire.

The other part of the junction was to the former Cotgrave colliery.

Rectory Junction is 123 miles 76 chains (199.48 km) from King's Cross.

Figure 67 is after closure when all its functions had been taken over by Trent Power Box. The missing nameplate is the giveaway to inactivity. The box originally had eighty-four levers. November 2014.

Figure 68 and a Class 158 – 158 783 – heads for Nottingham on the Down line. On the Up side the Total oil terminal sidings complex is clearly visible. Note the trap point on the exit road from the sidings, which is meant to derail any vehicle that attempts to leave when the junction point is not set. Any derailment here may end up in the River Trent. November 2014.

Figure 69 shows a train of EWS branded oil tankers from the Total oil terminal leaving for the west. Class 60, 60091 *Barry Needham* crawls over the Radcliffe Viaduct having just crossed the Trent on the Rectory Junction cast-iron bridge. The bridge was built by Clayton Shuttleworth of Lincoln in 1850. November 2014.

Bingham (BM)

Date Built	GNR Type or Builder	No. of Levers	Ways of Working	Current Status 2015	Listed Y/N
1875	GN Type 1+	40	AB	Closed	N

Figure 70 and, windows and steps apart, Bingham signal box is quite original. The box was extended in 1922 and the brickwork and locking frame windows clearly show this work. The uPVC windows have been sympathetically done and resemble the originals. May 2006.

Bingham was developed by the railway into a commuter town for Nottingham. Bingham station is 119 miles 39 chains (192.30 km) from King's Cross.

Figure 71 and looking towards the box and Nottingham from Bingham station platform. The two section signals for the crossing are in view, as is the original goods shed, which now sees another use. The trailing crossover looks as though it sees occasional use together with its reversing ground disc signals. May 2006.

Figure 72 and two more section signals from Bingham signal box. After Rectory Junction closed, Bingham works TCB to Derby Signalling Centre and AB to Bottesford West Junction. May 2006.

53

Bottesford West Junction (BW)

Date Built	GNR Type or Builder	No. of Levers	Ways of Working	Current Status 2015	Listed Y/N
1876	GN Type 1+	40	AB	Closed	N

Bottesford the village is just in Leicestershire and is close to Belvoir Castle.

Bottesford West Junction is a survivor of four boxes, similarly geographically named, which controlled the meeting of two lines.

Bottesford West Junction signal box is 113 miles 78 chains (183.42 km) from King's Cross.

Figure 73 shows the box in good condition but with plain windows for the operating floor, and yet some attempt at following the original with the locking frame windows. As there is no junction of any sort or exchange goods facilities any longer, most of the levers are plainly white. May 2006.

Figure 74 and Class 170, 170 505, draws into Bottesford station on its way to Sleaford and Boston. The original station buildings still exist here on the Up side. May 2006.

Allington (AL)

Date Built	GNR Type or Builder	No. of Levers	Ways of Working	Current Status 2015	Listed Y/N
2005	Network Rail Gabled	Nx Panel	AB, TCB	Closed	N

Allington is the first village on the line in Lincolnshire.

Allington signal box replaced a GN box called Allington Junction, but Allington is still a junction whereas Bottesford has ceased to be one, although is still named as such.

The boxes around the junction with the East Coast Main Line were modernised in 2005 and Barkston East Junction, the other side of the ECML, was done away with. Trains that travel from Nottingham to Sleaford mostly now call at Grantham using the Allington chord connection.

Allington signal box is 108 miles 70 chains (175.22 km) from King's Cross.

Figure 75 depicts a signal box that is spick and span and so it should be at only a few months old. The panel fitted within to control the colour light signals and points is termed an Nx panel; this refers to the function of eNtrance eXit, where tracks come in from the left of the panel and go out on the right.

In this case they go from Nottingham and out to Sleaford and also via a double junction to Grantham on the ECML. The action is to switch a route by a single switch from one side of the panel at the trains proposed entrance to the controlled area and another to control its exit. The electrical relay locking system works out which points and signals need to be changed. There are also discrete point and signal switches, but these are usually left in automatic mode. The panel was manufactured by TEW of Nottingham. May 2006.

Ancaster (AR)

Date Built	GNR Type or Builder	No. of Levers	Ways of Working	Current Status 2015	Listed Y/N
1873	GN Type 1+	30	AB	Active	N

Ancaster is an ancient settlement dating to Roman times and the parish church of St Martin is a Grade 1 listed building.

Ancaster signal box is 114 miles 53 chains (175.22 km) from King's Cross.

Ancaster signal box at Fig. 76 is rather ancient and thought to date from a time before even block working was established on this line. The records show that this signal box was interlocked in 1880.

The box is still of the period though with a brick-built lamp room at the end and wooden steps, but curiously no locking room windows, although the pattern on the brickwork suggests there may have been some. The wooden-gated Pottergate Lane sees very little road traffic, although the gates are interlocked with the signals. May 2006.

Figure 77 and the goods shed at Ancaster is in other use but almost as built. Note that there is a period station running board and mixed colour light and semaphore signalling. The view is towards Nottingham. May 2006.

Figure 78 is looking towards Sleaford and there is a conveyor unit above the running lines, and just by there is the Up refuge siding. The brake van at the end of the siding is originally of LNER design, which were later adopted as a BR standard. May 2006.

Figure 79 and Class 156, 156 404 scurries past the box on its way to Nottingham. May 2006.

Rauceby (RY)

Date Built	GNR Type or Builder	No. of Levers	Ways of Working	Current Status 2015	Listed Y/N
1880	GN Type 1	5 IFS Panel	AB	Active	N

Fig. 80 and Rauceby signal box looks a good deal older than some of the equipment within. It is equipped with an IFS, or Individual Function Switch panel, where all points and signals are electrically controlled. The only use for the lever frame is to work the locks on the wicket gates and they did have a use as detonator placers. February 2005.

Rauceby station originally served Rauceby Mental Hospital, but now sees commuter traffic from recently built housing estates.

Rauceby station is 118 miles 39 chains (190.69 km) from King's Cross.

Fig. 81 is the other side of the road at Rauceby and there are period running in boards here too. The crossing keeper/station master house is pure Great Northern with the scalloped barge boards. The crossing gates are quite substantial with massive concrete posts. February 2005.

Sleaford West (SW)

Date Built	GNR Type or Builder	No. of Levers	Ways of Working	Current Status 2015	Listed Y/N
circa 1880	GN Type 1	46	AB	Active	N

It is just less than two miles from Rauceby station to Sleaford West, which supervises the chord from Sleaford North that was featured in the Lincoln to Peterborough section. This chord was originally double but is now single track.

There was a small group of sidings that included a cattle dock and long headshunt to avoid shunting taking place on the running lines. It also handles the west end of Sleaford station, which retains three platforms.

Sleaford West is 120 miles 33 chains (193.79 km) from King's Cross.

Figure 82 depicts the box with its seemingly obligatory crossing with wooden gates. Unusually the gates have to cover three tracks – the Up and Down running lines and the shunting neck or headshunt. The station is to the right and the line from Sleaford North comes in from the right, although the actual junction is some way up the line. The box has been extended at the left-hand end. February 2005.

Fig. 83 and across the tracks now from the previous figure by the crossing, but the signal box is behind the camera. The headshunt is the nearest track with wooden sleepers and bullhead rail, and that has an elevated ground disc signal whose backlight is shining at us. The chord and Down running line both have home and distant signals on the same post, as well as route indicator, calling on arm and subsidiary arm to access the sidings.

The main running lines are headed for Rauceby and Nottingham. February 2005.

Fig. 84 is the view to the left of the box. The left-hand running line nearest the camera is the Down main line towards platform 1 of the station in the distance and eventually Boston. The next running line is the Up towards Nottingham and the crossover allows trains to access the chord to Sleaford North, which is on the Down side. Up trains use platform 2 here where the V of the platform ramp between platform 2 and 3 can be seen.

The next track is a loop line that runs into platform 3 and from that are the sidings and headshunt we saw running past the box. The solitary semaphore subsidiary armed signal is the siding group exit signal.

Sleaford East (SE)

Date Built	GNR Type or Builder	No. of Levers	Ways of Working	Current Status 2015	Listed Y/N
circa 1882	GN Type 1	50	AB	Active	Y

Sleaford East is 120 miles 58 chains (194.29 km) from King's Cross.

Fig. 85 sets the scene and it's enough to make anyone see red. Sleaford East is on the right and by the crossing barriers. The loop line from platform 3 comes out right by the box and the track goes single straight after the crossing. Sleaford station is a delight and all the more so as the island platform building is a rare wooden survivor. Note how platform 3 is signalled for bi-directional traffic from the double feather on the colour light signal over the crossing to the platform starter for the opposite direction. February 2005.

Fig. 86 Sleaford East has been a familiar structure to pedestrians and motorists for many years, as everyone held up on Grantham Road and at Southgate Crossing has had the opportunity to study the box at length. Another listed GN building with a chimney stack and pot to complete a substantially externally original signal box. April 2015.

Heckington (HN)

Date Built	GNR Type or Builder	No. of Levers	Ways of Working	Current Status 2015	Listed Y/N
1876	GN Type 1	18	AB	Active	Y

Heckington is a delightful and prosperous village that has an organisation that looks after the station. The line which set out from Sleaford as single track doubles up here and proceeds to Hubberts Bridge with some modernised colour light signals until the next section is reached.

Heckington signal box is 125 miles 54 chains (202.25 km) from King's Cross.

Fig. 87 is a bit of a cliché in that Heckington signal box is usually portrayed with the windmill, but that does seem its best aspect. The modernised semaphore signal post does duty at the Forth Bridge in its spare time. April 2015.

Fig. 88 and the signaller has been out, clad in the hi-viz jacket, to close the gates. Class 56, 56 078 approaches with a train of empties and is heading for Boston docks and another load of imported steel. April 2015.

63

Fig. 89 and Class 56, 56 078 heads for Boston past the old goods shed and original wooden waiting shelter at Heckington station. April 2015.

Fig. 90. Finally at Heckington is the Down distant looking towards Boston. The windmill gets into the act again. April 2015.

Hubberts Bridge (HB)

Date Built	GNR Type or Builder	No. of Levers	Ways of Working	Current Status 2015	Listed Y/N
1961	BR Eastern Region Non Standard	25	AB	Active	Y

Hubberts Bridge is a village near Boston that got its name from a bridge across the South Forty Foot Drain that was dug to drain the land, originally to make it suitable for farm land. The bridge is almost part of the railway infrastructure as the road that crosses the bridge is a manually gated crossing by the signal box.

Hubberts Bridge signal box is 133 miles 43 chains (214.91 km) from King's Cross.

Fig. 91 is the distant that is the first semaphore after Heckington. The A1121 road is on the left and the Forty Foot Drain is the other side of the embankment. April 2015.

65

Fig. 92 and 156 406 is slowing down for the next piece of single track at Hubberts Bridge. It has passed the distant signal in the previous view and the next home signal, whose backlight is just visible, between the DMU and off signal. The signaller has been quite quick in returning the arm to danger. The caption above the driver's head says the destination is Skegness. April 2015.

Fig. 93 shows the camera swung round from the previous view to show Hubberts Bridge signal box and the signaller within still has the hi-viz jacket on as the gates will need to be manually opened after the train has passed onto the single line. It did not stop here, so presumably this is a request stop. The bridge itself is just by the right-hand crossing gate. April 2015.

66

Fig. 94 is the final signal at Hubberts Bridge and this distant signal is the cautionary signal for the back of the 'on' home signal we saw at the station in the previous view. The view is towards Heckington. April 2015.

West Street Junction (WS)

Date Built	GNR Type or Builder	No. of Levers	Ways of Working	Current Status 2015	Listed Y/N
1874	GN Type 1	36	AB, TCB	Active	Y

West Street Junction signal box – Fig. 95, is shown unusually from the rear because it has this unique porch-cum-hut melded on the back in the same style as the rest of the building. The box supervises Boston station and environs and a very busy road crossing in Boston town centre. April 2015.

Boston is an administrative centre for the surrounding mainly agricultural area, as well as an inland port on the River Witham.

Boston station is 107 miles 24 chains (172.68 km) from King's Cross.

Fig. 96 and the layout at Boston station is clearer. The double track coming in is actually a long loop that enters and leaves the town as single track. Beyond the box the line splits into two to head off to Boston docks, again single track. The main customer for freight at the docks is imported steel and there are a couple of sidings where the wagons for these trains are stabled, presumably to await a ship's arrival on the River Witham on the tide. These are beyond the Aldi store. Speaking of which, there is a home signal facing the camera just by the roof of the store.

Just by the speed restriction roundel sign after the crossing is an elevated ground signal and its partner for reversing over the crossover is at the bottom of the picture. The Up platform starter on the far left is a substantial bracket signal with only one doll or post now. There were clearly through running tracks here for freight trains originally. The view is towards Hubberts Bridge. April 2015.

68

Now there is a short excursion to the Boston Docks.

Fig. 97 and the Skegness end of Boston station with two pairs of sidings, one for DMU stabling on the right, which also has a subsidiary armed signal to exit the sidings. The sidings on the left have a modernised ground signal whose red light can just be seen by the lamp post, as well as a colour light platform starter on the Down side for Skegness. Boston station building is a fine edifice and like so many others much of it is in other use now. The scene is rounded off by yet another road crossing as the line departs to Skegness single track. April 2015.

Boston Docks Swing Bridge (–)

Date Built	GNR Type or Builder	No. of Levers	Ways of Working	Current Status 2015	Listed Y/N
1887	Boston Corporation	12	Gate Box	Active	Y

Boston Docks Swing Bridge signal box controls the operation of the swing bridge across the River Witham and its associated road crossing. The bridge is normally left open to river traffic and, when the bridge has to be closed to let a train across the road, the crossing is closed.

As this box is not on NR, no mileage is given.

Back to the main line now and the journey continues north towards Skegness.

Fig. 98 and the grey girder-like object in the background is the bridge open. The crossing gates are manually opened and interlocked with the signal. The home signal is an LNER lattice post with a GN somersault arm, which pivots the arm away from the post to stand clear of it.

This design came about as a result of an accident at Abbot's Ripton in January 1876 in what is now Cambridgeshire on the GN main line; up until then Great Northern signals had a slot in the post into which the arm disappeared when it was off. This meant that the signal arm could be frozen in position by snow and ice in the OFF or go position, even when selected ON. The resultant collision cost thirteen deaths and fifty-nine injuries. May 2007.

Fig. 99 and the approach to the road crossing is guarded by another home signal. Note the double railed trap point on a running line – most unusual, but preferable to have a derailed train than one in the river. May 2007.

70

Fig. 100 is the end of the line when the bridge is open. Boston Docks are in the background.

Sibsey (S)

Date Built	GNR Type or Builder	No. of Levers	Ways of Working	Current Status 2015	Listed Y/N
1888	GN Type 1	IFS Panel	TCB, AB	Active	N

Sibsey is out in the fenland around Boston where the fertile ground can produce two crops a year.

Sibsey signal box is 112 miles and 7 chains (180.39 km) from King's Cross.

Sibsey signal box has been modernised, at least on the inside, where there is an Individual Function Switch panel to operate the colour light signals and the junction point – Fig. 101. The double track is resumed from here to Skegness. The substantial station building is opposite the box and now in private use. May 2007.

71

Bellwater Junction (BJ)

Date Built	GNR Type or Builder	No. of Levers	Ways of Working	Current Status 2015	Listed Y/N
1913	GN Type 4a	25	AB	Active	N

Bellwater Junction was once the junction for a line coming in from Woodhall Junction, which connected to Lincoln and Louth. The line clung on until 1970. The Railway Cottages, which are close to the box, live on as a reminder.

Bellwater Junction signal box is 118 miles and 56 chains (191.03 km) from King's Cross.

Bellwater Junction signal box is back to brick after the brief flirtation with wood at Sibsey, and the brickwork to the rear looks like a rebuild – Fig. 102. There is a trailing crossover here. April 2008.

72

Fig. 103. After the narrow lane crossing the Bell Water Drain has to be bridged before a train can proceed to Skegness. Note that there is manual gate locking mechanism rising from under the track. The building in the distance is a former crossing keeper's cottage. April 2008.

Fig. 104 and the line stretches straight back towards Sibsey and Boston. Note that there is no ground disc to signal a reversing move over the crossover so it would need hand signals from the box with flags or a Bardic lamp at night. Note also that some of the crossing timbers are irregular lengths and are obviously replacements for rotten timbers that have been slid into place. April 2008.

Thorpe Culvert (TC)

Date Built	GNR Type or Builder	No. of Levers	Ways of Working	Current Status 2015	Listed Y/N
2003	Network Rail Gabled	IFS Panel	AB	Active	N

The line originally travelled up to Firsby Junction, which had been a meeting place of two branch lines as well as the main line, as it then was, from Boston to Louth. The journey now continues on what was the Firsby to Skegness line and this explains the rather odd nature of the line's curvature around here and the mileage change.

Thorpe Culvert signal box is 2 miles and 21 chains (3.64 km) from the former Firsby Junction.

Fig. 105. Thorpe Culvert signal box. Thorpe Culvert had a GN box for years but it was patched up and became dilapidated to such an extent that the only solution Network Rail had was to demolish it and build a new one. The mechanical signalling was removed when the GN box was pulled down. There is a GN waiting room building on the Down platform. April 2015.

Wainfleet (W)

Date Built	GNR Type or Builder	No. of Levers	Ways of Working	Current Status 2015	Listed Y/N
1899	GN Type 1	25	AB	Active	Y

Wainfleet All Saints is forever associated with Bateman's Brewery who have had their premises in Wainfleet since 1874 and continue to this day.

As access to most of the signals is quite easy, and there are wire worked distant signals here, the approach taken here is a brief journey across the box's signal diagram, so to speak.

Wainfleet signal box is 4 miles and 15 chains (6.74 km) from the former Firsby Junction.

Fig. 106 and the distant is plated W 1 as the first signal on the line coming from Thorpe Culvert and Boston, the Down side. The next home signal along the line is the one at the end of the Down platform at Wainfleet station, which is just visible.

The red flashing lights are permanent reminders to drivers that there is a crossing ahead. Road users have their own warning lights that only operate when a train is near. The grey units between the rails on the Up right-hand track are treadles that return the barriers to the raised position after a train has passed. These are interlocked with the Down side in case a second train is approaching from that direction. April 2015.

Fig. 107 and Class 156, 156 415 heads towards Boston past the home signal we could just see in the previous figure. The sign that resembles a hot cross bun is a Network Rail sign for a crossing – the crossing we saw previously.

The GN station waiting room building has seen it all before over the previous 135 years. Worthy of note is the early block paved platform surfaces. April 2015.

Fig. 108, harking back a few years to when Wainfleet signal box had a gate wheel and mechanically cranked gates. The box has had two extensions to the chimney stack. Note that there is an Up line home signal with sighting board round the bend to the left. The original station building is present, on the left, though in other use and the cast-iron railings on the left, which are moulded with the initials GNR near the foot of the posts. The view is towards Skegness. May 2007.

Fig. 109 and the location is the junction, almost, of the A52 road and Dovecote Lane. This distant signal is a cautionary for the sight boarded home signal in the previous figure and we are now looking towards Boston. Note that there is a crossing keeper's cottage up the line, but on the Down side. April 2015.

Skegness (–)

Date Built	GNR Type or Builder	No. of Levers	Ways of Working	Current Status 2015	Listed Y/N
circa 1882	GN Type 1	80	AB	Active	Y

77

Fig. 110 and Skegness signal box is a sizeable building that didn't start out quite so big. In 1900 an extension was put on the far end that upset the symmetry of the structure. The wooden staircase extending down to the track is an unusual feature and the platform itself is a modern concrete prefabricated edifice. The slate roof shows signs of a stove removal. April 2015.

Fig. 111 is showing all six platform starter signals at Skegness. There had been seven platforms here but platform 1 over by the brick wall and the spiky fence on the right has been dispensed with. Consequently we have, from right to left, platforms 2, 3, 4, 5, 6, and 7. Each starter has a subsidiary arm or elevated ground disc to signal a move into the carriage sidings, of which only the Northern Group on the right remain. Note that platform 7 on the far left has a steadying post and a guy wire. Also worthy of note is the bracket signal for platform 4, which is past the box. This is the longest platform and is the only one with a loco release crossover, which means the passenger coaches would need to be pushed back to enable the loco to be released, but could not of course pass the signal arm at danger, hence its distant position. April 2015.

Fig. 112 and the business end of Skegness station in terms of track layout. The two tracks on the extreme left are the lead in to platforms 7 and 6 and there is a double slip there to allow trains to head off to Boston or the carriage sidings. The track for platform 5 towards the centre of the picture also uses the same double slip. Next to that is a further double slip that lets Up trains access platforms 6 and 7. The crossover towards the right lets trains access platforms 2 and 3, and those platforms access the carriage sidings. There are three carriage sidings behind the small subsidiary arm. Note how the carriage sidings exit point is set in the direction towards the trap point on the far right.

The other crossover on the two running lines is to enable trains from platforms 2, 3 and 4 to access the Down main line to Boston.

The Up line coming in from Boston has two home section signals and beyond that is a distant, which is about a mile from the box we will glimpse later.

The walkway beyond the crossover ground signal is a public footpath from round the back of the Tesco store and across all running lines and carriage sidings. The milepost on the right has the mileage from Firsby Junction. April 2015.

Skegness was catapulted into fame by the railway poster of 1906 by the artist John Hassall. It was commissioned by the Great Northern Railway and depicted the 'Jolly Sailor' reminding everyone that 'Skegness is so Bracing'.

Into this mix, in 1936, went Billy Butlin's Holiday Camps, and the first of the camps was at Skegness. He promised 'a week's holiday for a week's pay' and, as 1936 was the advent of holidays with pay, the camp was an immediate success; this meant a railway station that grew with facilities to cope with the throngs of holidaymakers and to cope with many extra holiday trains.

Skegness signal box is 9 miles and 5 chains (14.58 km) from the former Firsby Junction.

Fig. 113 is the view from the footpath in the previous figure, looking back towards the buffer stops at Skegness station. There is only one ground disc for the crossover because it's only a reversing move over the crossover from the Up main line. The imposing building at the rear of the station canopies is the Lumley Hotel, and whilst some of the station buildings have been demolished, the canopies to shelter passengers who are queuing for buses to Butlin's remain. The carriage sidings come in from the far left and there is just one signal to exit. April 2015.

80

Fig. 115 is another view that is still on the footpath and the exit from the carriage sidings, which are loops. There is just one signal and so that means any points are hand operated by lever, as shown by the example white lever on the left; this means trains can exit the carriage sidings from any of the three roads, but by one signal. April 2015.

Opposite page below: Fig. 114 is a view still on the footpath, but looking towards Boston. The crossing is just over a mile from the box. The distant is the first of the Skegness signals and the crossing at Croft is beyond that. April 2015.

Fig. 116 and the loco release crossover for platform 4 at Skegness station has manual point levers but the crossover has facing point locks that must be released from the signal box. The grey box and point rodding between the rails is the facing point lock mechanism. Notice how there is only one signal box lever for this dual function as the movement is transferred to the other point by bellcranks and rodding. The Class 156, 156 404 has arrived at platform 3 and now has the red and white striped 'Not to be Moved' sign on it. April 2015.

East Coast Main Line and Doncaster to Gainsborough

East Coast Main Line to Doncaster and Gainsborough.

This journey travels north through the GN racing ground from Cambridgeshire to Yorkshire, with a brief foray away from the overhead wires from Doncaster to Gainsborough in Lincolnshire, Fig. 117. All the boxes depicted have no block post responsibility for controlling trains and as such are termed 'Gate' boxes. In addition, they have no mechanical signalling so the treatment is somewhat cursory, and on a very largely modern electrified and automated railway, it is surprising they have survived at all.

Offord (–)

Date Built	GNR Type or Builder	No. of Levers	Ways of Working	Current Status 2015	Listed Y/N
1976	BR Eastern Region Type 20	IFS Panel	Gate	Closed but used in Emergency	N

Offord signal box, Fig. 118, was de-staffed in 1998 and is only used if there are barrier failures from the control at Peterborough Power Signal Box. It is used to locally control the barriers but this function is 'slotted' or remotely interlocked with the line running signals, still from Peterborough. There are quadruple tracks at this location and the line speed of the faster tracks is 100 mph (160 km/hr). October 2006.

The Offords are small villages in Cambridgeshire that link up with the delightful village of Buckden, which was also rail served.

Offord signal box is 55 miles 76 chains (90.04 km) from King's Cross.

84

Helpston (–)

Date Built	GNR Type or Builder	No. of Levers	Ways of Working	Current Status 2015	Listed Y/N
1898	GN Type 1	IFS Panel	Gate	Closed but used in Emergency	N

The signal box at Fig. 118 is remarkably original. Note that there is a bricked up rodding and wires channel under the front wall. GN signal boxes don't often have walkways around the first floor windows and there is no 25 kV system wire mesh grilling on the windows.

The crossing keeper's cottage behind the signal box has retained its scalloped barge boards despite it being in private use now. May 2007.

The box is between the GN quadruple track ECML and the double track MR route. The box is only an emergency control panel for the level crossing barriers, should there be a failure at Peterborough PSB.

Helpston signal box is 81 miles 56 chains (131.48 km) from King's Cross.

Tallington (–)

Date Built	GNR Type or Builder	No. of Levers	Ways of Working	Current Status 2015	Listed Y/N
1975	BR Eastern Region Type 20	Nx Panel	Gate	Closed but used in Emergency	N

Fig. 120 and Tallington in action, or rather not as this box is the same as Offord in that it is only open when Peterborough's control of the barriers fails and the local Nx panel has to be used. There is also a set of 'ladder' crossovers at Tallington where trains can access the Down lines from the Up and other crossovers between Up slow and fast lines. There are also sidings for the Redland and Tarmac companies at the survey date. February 2005.

Into Lincolnshire at Tallington and the village was home to Dowmac concrete products. Tallington signal box is 84 miles 64 chains (136.47 km) from King's Cross.

Claypole (–)

Date Built	GNR Type or Builder	No. of Levers	Ways of Working	Current Status 2015	Listed Y/N
1977	BR Eastern Region Type 20	Nx Panel	Gate	Closed but used in Emergency	N

Fig. 121. The line has been reduced to double track by this point but Claypole has Up and Down loops with a pair of crossovers to access them. June 2007.

Still in Lincolnshire, but right by the Nottinghamshire border, is the village of Claypole.

Claypole is yet another emergency gate box; Peterborough always retains control of the signalling and a release is required from Peterborough to operate barriers locally.

Claypole signal box is 115 miles and 27 chains (185.62 km) from King's Cross.

Barnby (–)

Date Built	GNR Type or Builder	No. of Levers	Ways of Working	Current Status 2015	Listed Y/N
1977	BR Eastern Region Type 20	IFS Panel	Gate	Closed but used in Emergency	N

Should the remote operation of the barriers fail then Barnby signal box would be staffed by an emergency gate keeper who would operate the barriers locally but with reference to Doncaster Power Signal Box at the survey date – Fig. 122. The ground floor of the box is a relay room. June 2008.

Just over the border into Nottinghamshire now and Barnby in the Willows is a small village near Newark on Trent.

Barnby signal box is 119 miles and 3 chains (191.57 km) from King's Cross.

87

Bathley Lane (–)

Date Built	GNR Type or Builder	No. of Levers	Ways of Working	Current Status 2015	Listed Y/N
1930	GN Type 4b	IFS Panel	Gate	Closed but used in Emergency	N

The LNER was much occupied in the early 1930s with replacing mechanical signals in some areas with colour light signals and only brought out its own signal box designs later – Fig. 123. June 2008.

North of Newark now and Bathley Lane signal box is a Great Northern pattern signal box, but one built by its successors, the LNER.

Bathley Lane signal box is 119 miles and 3 chains (191.57 km) from King's Cross.

Carlton (–)

Date Built	GNR Type or Builder	No. of Levers	Ways of Working	Current Status 2015	Listed Y/N
1977	BR Eastern Region Type 20	Nx Panel	Gate	Closed but used in Emergency	N

Fig. 124. Carlton signal box is also supervised by Doncaster PSB as an emergency barrier gate box but is also used to practice emergency deployment of signallers in the simulation of a real emergency. There are passenger train loops here and a pair of crossovers to enable trains to access those loops. There is a Westinghouse VDU terminal for local control. June 2008.

Carlton on Trent is a small village north of Newark.
Bathley Lane signal box is 126 miles and 25 chains (203.28 km) from King's Cross.

89

Grove Road (–)

Date Built	GNR Type or Builder	No. of Levers	Ways of Working	Current Status 2015	Listed Y/N
circa 1880	GN Type 1+	IFS Panel	Gate	Closed but used in Emergency	N

Grove Road signal box appears to be in splendid condition – Fig. 125. The rear brickwork appears to be a rebuild at some point but the nameplate is of an LNER-era production. The box was re-windowed in the 1970s. The crossing is normally supervised by Ranskill further up the line. June 2008.

Grove Road signal box is just south of Retford and the place where the Great Central line from Sheffield and Worksop passes under the ECML.

Grove Road signal box is 137 miles and 37 chains (221.22 km) from King's Cross.

Barnby Moor and Sutton (–)

Date Built	GNR Type or Builder	No. of Levers	Ways of Working	Current Status 2015	Listed Y/N
1872	GN Type 1	None	Gate	Closed but used in Emergency	N

Although there is no signalling panel here, it retains a barrier pedestal control unit for local barrier control. Normal control of the barriers is undertaken by Ranskill signal box further up the line.

The box has had its name truncated to just Sutton and this is an admirable cost cutting measure by Network Rail as otherwise an extension to the box may have been necessary to accommodate the original name – Fig. 126. June 2008.

Barnby Moor and Sutton shared the name with the station, which closed in 1949.

Barnby Moor and Sutton signal box is 141 miles and 56 chains (228.04 km) from King's Cross.

91

Ranskill (–)

Date Built	GNR Type or Builder	No. of Levers	Ways of Working	Current Status 2015	Listed Y/N
circa 1875	GN Type 1	Nx Panel	Gate and Emergency Block Post	Active	N

Ranskill can supervise all signalling activity from Gamston crossovers to the south of Retford to Bawtry in the north, just south of Doncaster, should Doncaster PSB fail.

This is a distance of just over 12 miles (19.31 km). The box controls five crossings including its own, and the other four are by CCTV. Note the 144 mile post (231.75 km) a little way past the box – Fig. 127. June 2008.

Ranskill is a village north of Retford.

Ranskill signal box is 143 miles and 79 chains (231.73 km) from King's Cross.

Finningley (–)

Date Built	GNR Type or Builder	No. of Levers	Ways of Working	Current Status 2015	Listed Y/N
1877	GN Type 1	IFS Panel	Gate	Active	N

Finningley signal box looks quite original apart from the inevitable windows but they look the period part – Fig. 128. One of the original station platforms is on view and its partner on the Down side towards Doncaster supports the station building. The goods shed has also survived and there is a trailing crossover, but that is controlled by Doncaster PSB. June 2008.

Finningley in Yorkshire is perhaps most notable for the former Cold War Vulcan bomber base and air show.

Pinned to the fencing is a notice informing us of the mileage, which is 112 miles and 8 chains (180.41 km), calculated from Huntingdon South Junction via March.

Beckingham (B)

Date Built	GNR Type or Builder	No. of Levers	Ways of Working	Current Status 2015	Listed Y/N
1877	GN Type 1	IFS Panel	TCB, AB	Active	Y

Beckingham signal box. The box looks to be in almost original condition except for the locking frame room windows, which have been bricked up as a security measure, and the walkway boards – Fig. 129. Also visible are the chimney stack and end of a very individually designed and built goods office or weighbridge office. The surviving station building is similarly adorned. June 2008.

Beckingham is back in Lincolnshire and a pleasant village with listed church and pub.

Beckingham signal box is still worthy of mention as a listed building and, furthermore, it is an interface box between two ways of working. The box works Track Circuit Block to Doncaster PSB and Absolute Block to Gainsborough Trent Junction signal box, and supervises two goods loops at the survey date.

The mileage is 100 miles and 78 chains (162.50 km) from Huntingdon South Junction via March.

94

West Street Junction Signal Box and crossing Boston. April 2015.

Boston Docks Swing Bridge signal box with Great Northern armed signal. May 2007.

References and Acknowledgements

Acknowledgements

The kindness and interest shown by railway signallers.

References

Books and Printed Works

The works of Adrian Vaughan – various publishers
British Railways Pre-Grouping Atlas and Gazetteer – Ian Allan
L. T. C. Rolt, *Red for Danger* – Pan Books
Signalling Atlas and Signal Box Directory – Signalling Record Society
Quail Track Diagrams Parts 2 and 4 – TrackMaps

Internet Websites

Adrian the Rock's signalling pages
http://www.roscalen.com/signals

The Signalbox, John Hinson –
www.signalbox.org/

Wikipedia
http://signalboxes.com/